Drawn By Fire, Too

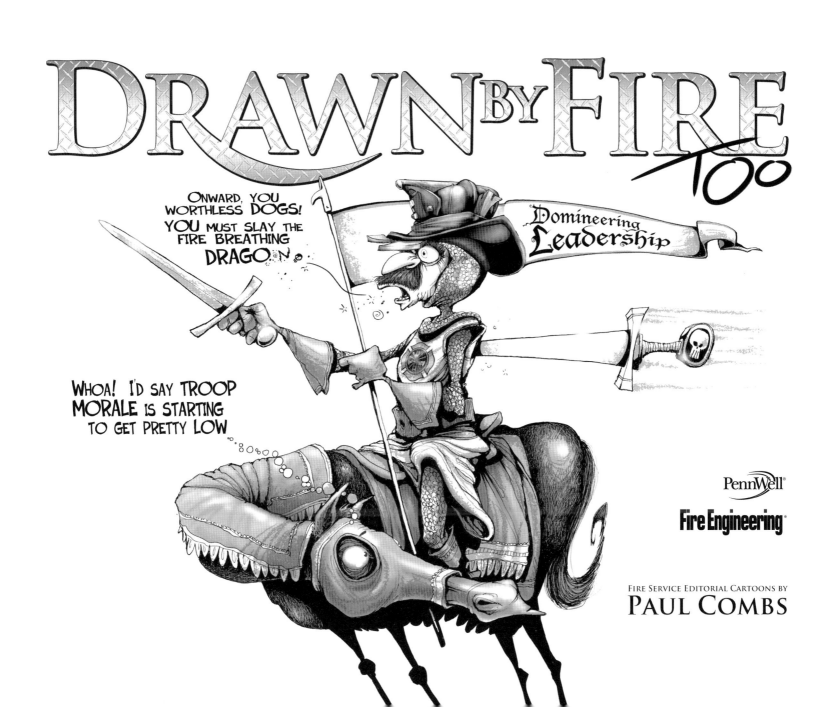

Copyright© 2014 by
PennWell Corporation
1421 South Sheridan Road
Tulsa, Oklahoma 74112-6600 USA

800.752.9764
+1.918.831.9421
sales@pennwell.com
www.Fire EngineeringBooks.com
www.pennwellbooks.com
www.pennwell.com

Marketing Manager: Amanda Alvarez
National Account Manager: Cindy J. Huse

Director: Mary McGee
Managing Editor: Marla Patterson
Production Manager: Sheila Brock
Production Editor: Tony Quinn
Cover Designer: Paul Combs

Library of Congress Cataloging-in-Publication Data

Combs, Paul (Paul David), 1966-
 Drawn by fire, too : fire service editorial cartoons / by Paul Combs.
 pages cm
 ISBN 978-1-59370-335-6
1. Fire fighters--Caricatures and cartoons. 2. American wit and humor, Pictorial. I. Title. II. Title: Fire service editorial cartoons.
 NC1429.C6435A43 2013
 741.5'973--dc23

 2013038074

Printed in the United States of America

1 2 3 4 5 18 17 16 15 14

For all my fire brothers and sisters–always make a difference and stay fired up!

CONTENTS

FOREWORD

The late historian and author Stephen Ambrose, speaking about the Civil War, said, "At the pivotal point in the war, it was always the character of individuals that made the difference." Our character as individuals is defined by our values and a distinctive set of personal qualities. The fire service as an institution is also defined by its values and a distinctive set of qualities that those of us practicing firefighting today display in our behavior, both good and bad. Our values are inalienable, and they underwrite the theme of every illustration drawn by the reverent hand of Paul Combs. Our personalities, however, are far more diverse, far more thought provoking and puzzling, and this is where the artistry of Paul Combs explodes.

The ability to capture a moment in art is one thing; the ability to interpret that moment and display its underlying meaning and broader implications is another. The ability to capture, interpret, and display a moment using humor—the most honest of all communication—is a rare and amazing gift. In the pages you're about to enjoy, you will marvel at how Paul Combs, because of his intimate and deeply personal relationship with the fire service, has that ability to not only capture our character but to interpret it in context with the challenges we face today. Paul's love of our fire service gives him the unique capability as an artist to not only see us for who we really are but to help us see ourselves as we really are. Paul does this in a daring way, defying convention and testing the very limits of what today is called political correctness within our institutions and our industry.

Paul has a deep and abiding respect for every man and woman engaged in the art of firefighting. He has disciplined himself and educated himself to a point where his honesty and integrity, not only as an artist but as a commentator on the fire service, is unquestionable. When one looks at the artistry of his illustrations, there is no end to the depth of this work. Every line, every nuance, every curve of a face or raise of an eyebrow has meaning far beyond the readily

apparent. Paul can take an extremely sensitive and controversial topic and show its complexity and its ambiguity in a way that no other illustrator working in the fire service has ever been able to achieve. For every smile that Paul brings to our faces in the subtlety and the irony that he captures in his art, there are ten thoughts that are brewing about the concept he just instantly and thoroughly captured.

The reason that Paul Combs has a capability unsurpassed in our beloved fire service for editorial excellence and editorial insight is that he is first and foremost a firefighter. Paul does not just opine about who we are. Paul puts on a uniform and reports for duty just like every other member of the bravest defending our nation today. Paul knowingly and willingly exposes himself to tremendous danger and risk, as does every other firefighter in America. He does so without reservation. He engages in professional firefighting out of a sense of duty, a sense of service, and a sense of loyalty to his community and his fellow citizens. Paul Combs is a firefighter. Paul is the one in a hundred. Paul is also a survivor, the type of survivor who was identified in writings by Laurence Gonzales in his landmark book *Deep Survival*, the one who sees the unique aspect of every situation, especially its irony, and captures it instantly for everyone else to learn.

Paul Combs is also one of the leading voices in crafting the behavior of the fire service in ways that are going to make us more effective and more meaningful in the lives of those we have sworn to protect. Paul understands the importance of the oath he took to the fire service, his country, and his community, and it is reflected with every stroke of his pen and in every comment he places on his art. Nothing is casual in Paul's leadership. Paul is a firefighter, he knows the duties of a firefighter, and he practices the art of firefighting, which gives his illustrations unparalleled credibility and depth. Only someone who is, knows, and does can lead. Paul does all three, and he does them with a commitment to excellence and always with his eye on providing outstanding service.

Paul does not shy away from controversial topics. In the pages that follow, you will see illustrations whose implications or objective you might not agree with. From time to time, Paul and I have had discussions about some of the topics and

themes he has chosen, and although we might not completely agree, we always agree that it is a discussion we must approach as gentlemen with honor and respect.

I'm honored that Paul allowed me to say a few words about his incredible work and about him—a man of character and integrity, a man who I am proud to call my friend, and a man whose work has brought me thousands of smiles, millions of thoughts, and countless hours of enjoyment. I know that as you turn these pages, your mind will race, your face will ache from having smiled harder than you have in a long time, and your heart will break at some of the incredible emotions that only Paul can capture. We will never be able to thank Paul enough for all his contributions. We can only hope that he will continue for many years to come to add his voice to this great fire service that he has so well captured and served over these many years. God bless you Paul and thank you for all you've done to make the world a better place and the fire service—a little happier and much healthier.

Fire Chief (Ret.) Bobby Halton
Editor-in-Chief, *Fire Engineering* magazine
Education Director, FDIC

INTRODUCTION

Let me start by saying: congratulations, you have made a wise purchase.

Everyone in the fire service knows that Paul Combs is an incredibly talented artist. What most people haven't figured out yet is that he is also one of the most influential fire service educators of our time. As human beings, we depend on our senses to process the information around us. To learn, most people tend to use their visual sense more than the others. This is the sense that Paul Combs connects with in a way that no one else can.

Those of us who have dedicated our lives to educating members of the fire service through books, seminars, and training are in awe of Paul's ability to tell a complete story with a single illustration. His skillful cartoons are funny, serious, and to the point. Every time you thumb through this book, you will find pictures that are centered on the exact message you will need to hear at that moment. I'm pretty sure every fire station in the country has at least one Paul Combs illustration hanging in the kitchen or dorm for that exact reason.

It's clear that Paul is not only talented, but also highly educated and completely in touch with the most relevant issues concerning today's fire service. As you turn each page, you will find yourself thinking that Paul must be a member of your department. How else would he know exactly what challenges you are currently encountering or themes you have been laughing at?

Yes, this book will make you smile, even laugh out loud, but it also has the ability to save lives. "Buckle your seatbelt; wear your mask when overhauling; don't hesitate to call a Mayday if you are in trouble; if you feel stressed seek help."

These are the types of messages every fire service leader should be preaching. They are also the exact type of messages that Paul Combs delivers better than anyone I know.

Enjoy *Drawn by Fire, Too*. Be prepared to be entertained and educated at the same time.

<div align="right">

Frank Viscuso
Deputy Chief, Kearny Fire Department
Author of *Step Up and Lead*

</div>

PRAISE FOR PAUL COMBS

When I decided to have a testimonial page, I started making a list of whom I'd like to invite. Please know this was not an easy task for me because I've spent the majority of my career eluding praise and attention—a by-product of being a hopeless introvert. However, I wanted to include my closest friends, colleagues, and respected mentors within the pages of this second collection of my work. Someday I want to look back over my career and know that the people who influenced me most had a sounding board in this book—a book that contains evidence of their impact on me.

In short, I don't let people get close to me for many reasons. But the few I have allowed in the door mean the world to me, and this is my way of saying, "Hey, I love you, man!"

Paul Combs

"Paul's contributions help put the fire service into focus, reminding us all to not take ourselves too seriously, but to ensure to take the job seriously. His passion has infected the fire service."

Deputy Chief Anthony Avillo
North Hudson (NJ) Regional Fire & Rescue

"I consider Paul's work like a seasoned company officer, coaching our firefighters and leading us along the right path by setting the example of what a firefighter and the fire service should be."

Division Chief Eddie Buchanan
Hanover (VA) Fire/EMS

"Using humor and emotion, Paul reaches us at our core, our shared values. Once there he educates us on safety issues, tactics, new trends, traditions and most of all the good and the not so good in the fire service."

Battalion Chief Jim Duffy
Wallingford (CT) Fire Department

"Paul is a firefighter, an artist, and teacher all in one. His art has a way of making you feel that he is speaking directly to you, or maybe sometimes about you."

Lt. Shane Furuta
Federal Fire Department, Pearl Harbor, HI

"We seem to never get enough of Paul's drawings . . . and we find ourselves awaiting the 'next' one like a kid waiting for the mail on their birthday."

Deputy Fire Chief Billy Goldfeder, EFO
Loveland-Symmes Fire Department, Ohio

"Paul is blessed with a rare and unique talent that allows his work to touch the heart, mind, and soul of those within this profession. His work forces us to look inward at ourselves and reflect upon what is good and that which needs to be corrected."

Battalion Chief Ed Hadfield
Santa Maria (CA) Fire Department

"With the wit of Mark Twain, the touch of da Vinci, and the fire savvy of Smoky Joe Martin—Paul Combs is a gift to the fire service!"

Paul Hashagen
Rescue 1 FDNY (ret.)

"He says, in one beautiful drawing, what legions of firefighters want to say, or want to ask."

Battalion Chief Anthony Kastros
Sacramento (CA) Metro Fire District

"Over the years my good friend Paul Combs has been referred to as an illustrator, firefighter, and brother, and his work has provoked discussions in the firehouse at the kitchen table, in the rig on the way back from a run, in staff meetings, on all of the social media outlets, and have been the catalyst for many training drills."

Chief Rick Lasky (ret.)
Lewisville (TX) Fire Department

"Insightful, timely, visual, gut-wrenching, accurate, educational, humorous are some of the words I use in describing Paul's work. Paul's insights to the relevant issues facing the fire service are accurately captured in his timely illustrations."

Deputy Chief John K. Murphy JD, PA-C, EFO (ret.)
Eastside Fire & Rescue

"As you look at Paul's art, ask yourself: Can I see myself or someone I know in that piece? In most cases the answer is yes. The more important question is what are you going to do about it?"

Jerry Naylis

"The education that Paul provides us through his illustrations is the epitome of fire service training and education."

Deputy Chief Paul "P.J." Norwood
East Haven (CT) Fire Department

"He delivers a humorous yet powerful message that can provide comfort to us as a fire service by letting us know we are not alone.

Deputy Chief Chris Pepler
Torrington (CT) Fire Department

"Ben Franklin (father of the editorial cartoon) would be proud of the body of work and the command of the pen demonstrated by Paul Combs. His contributions to the fire service will stand for the ages, capturing in a single illustration the essence of who we are and were we need to be."

Lt. Frank Ricci
New Haven (CT) Fire Department

"Whether he is tackling firefighter health, safety, stereotypes, chiefs, probies, training, or any other 'hot' topic in the fire service today, he does so with wit, talent, and pinpoint accuracy. He is drawing what the fire service is thinking!"

Diane Rothschild
Executive Editor, *Fire Engineering* magazine

"You look at the picture five times and each time you see something you haven't seen before."

Battalion Chief John Salka (ret.)
FDNY

Tactical Two-Step

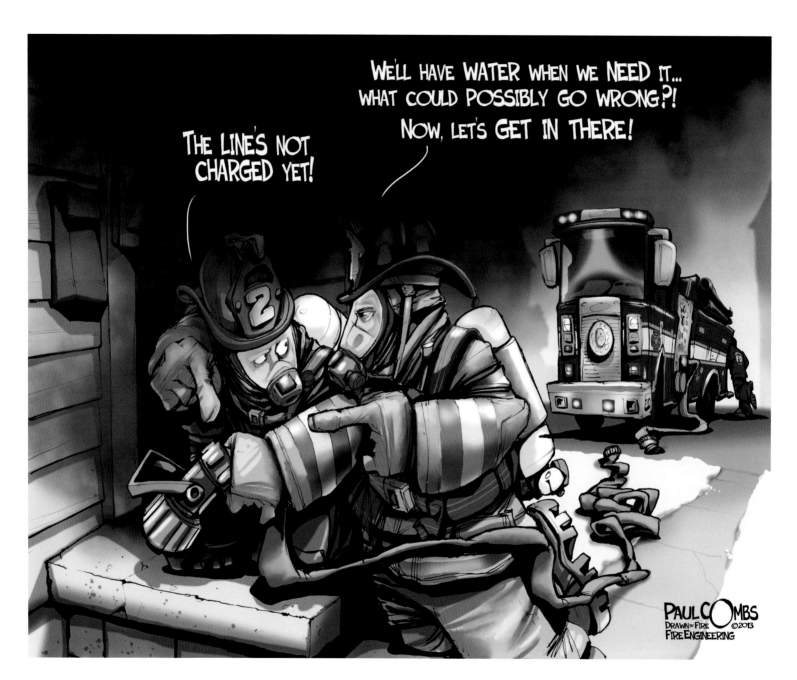

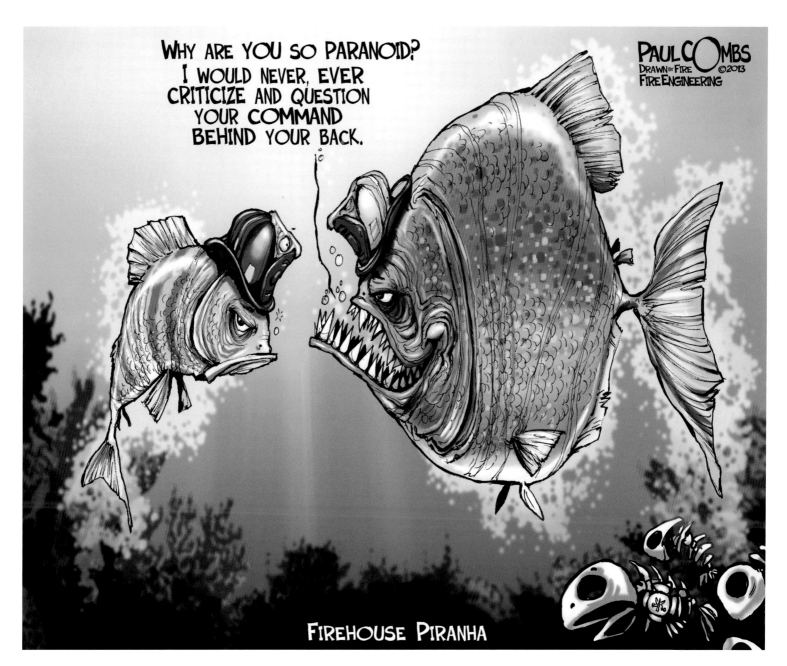

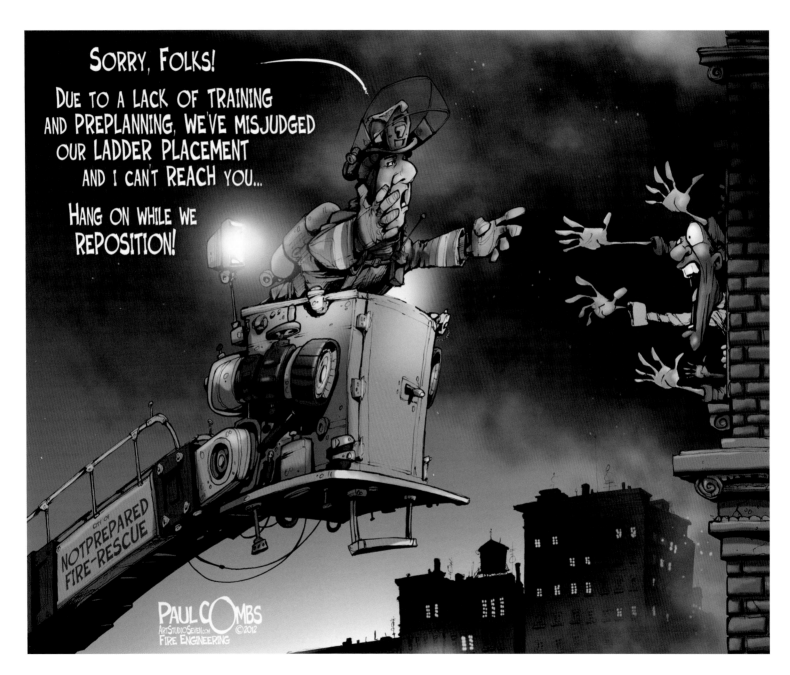

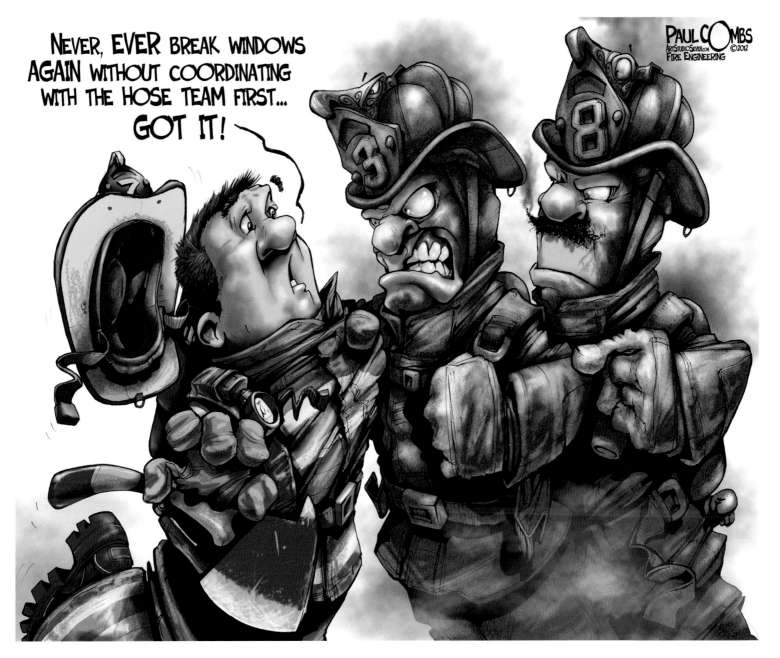

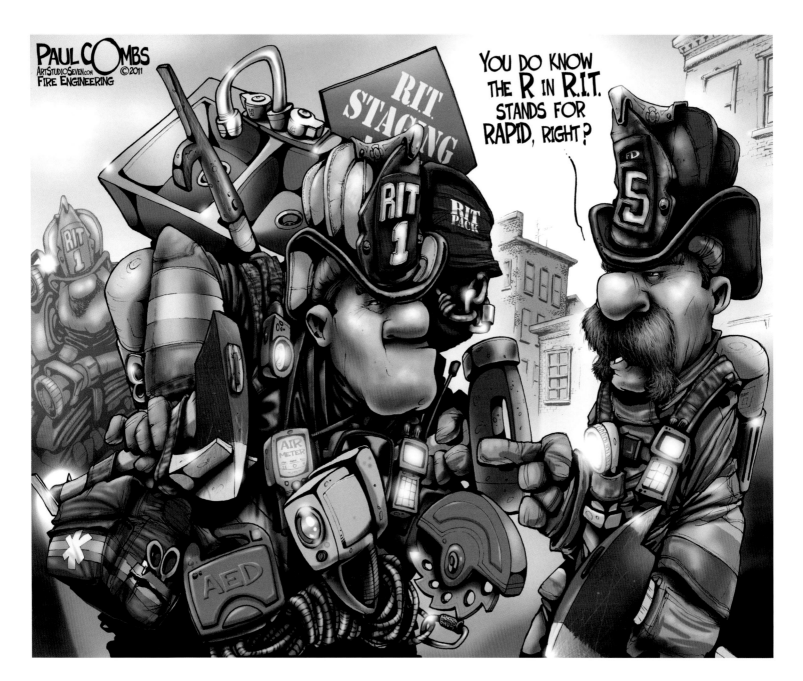

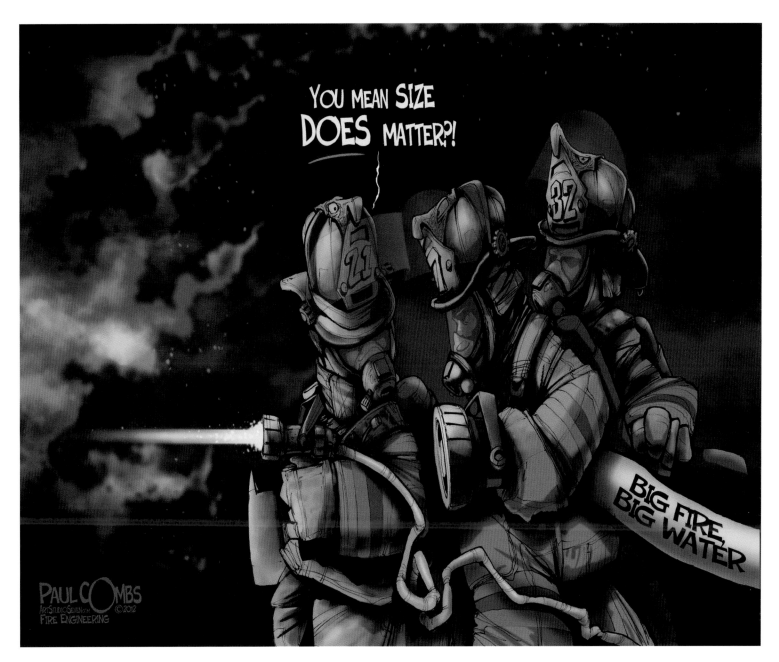

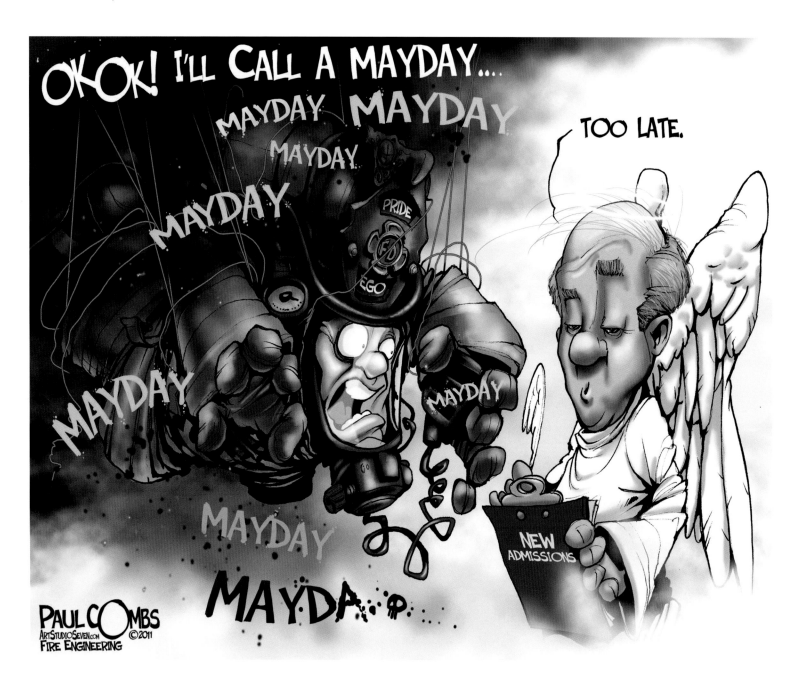

Leading from the Back Seat

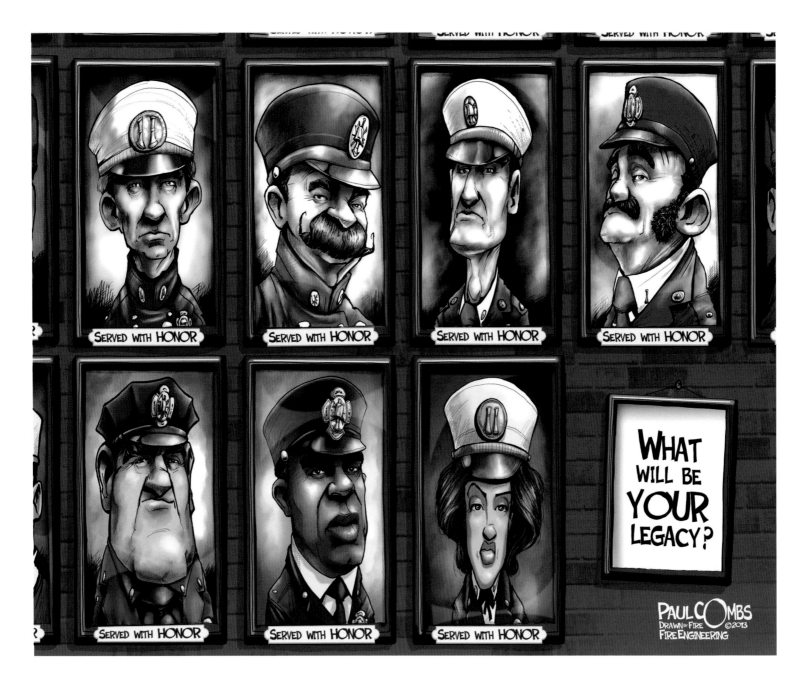

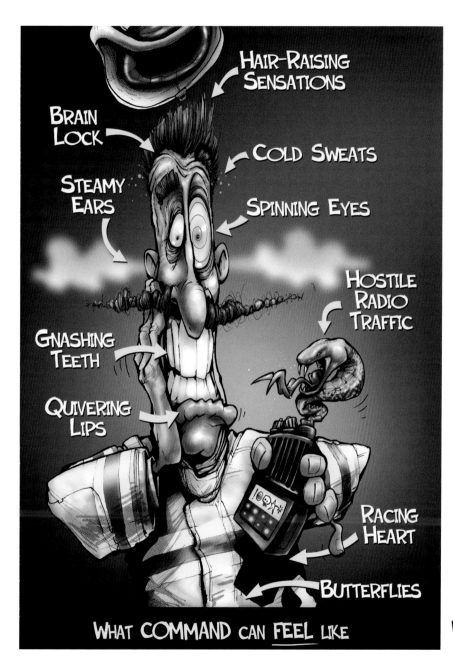

WHAT COMMAND CAN FEEL LIKE

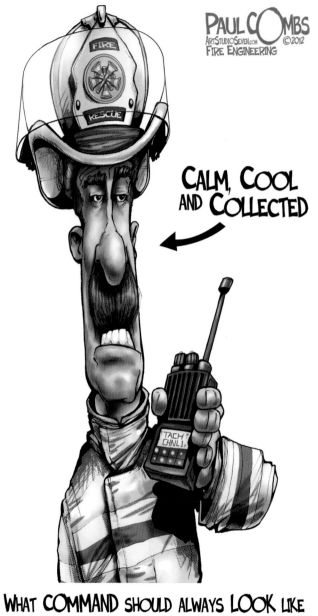

WHAT COMMAND SHOULD ALWAYS LOOK LIKE

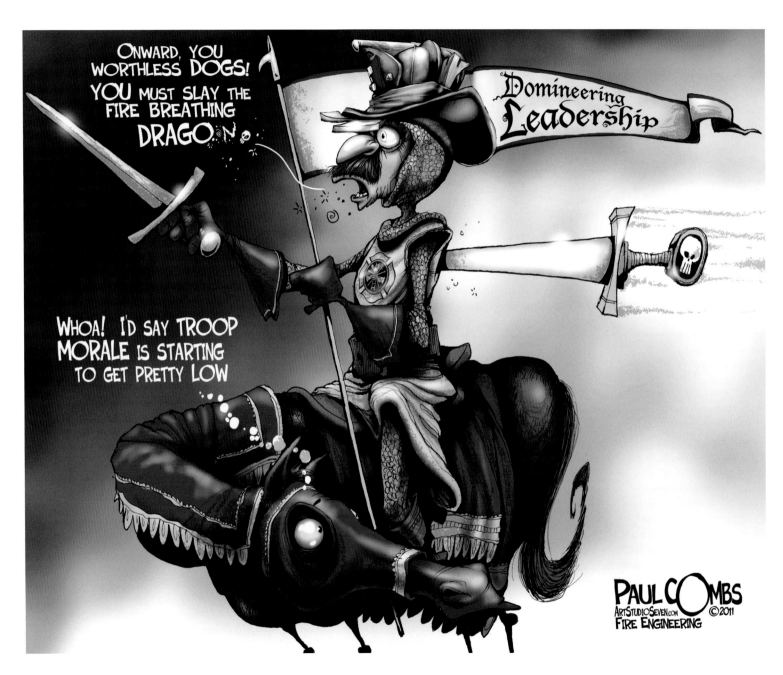

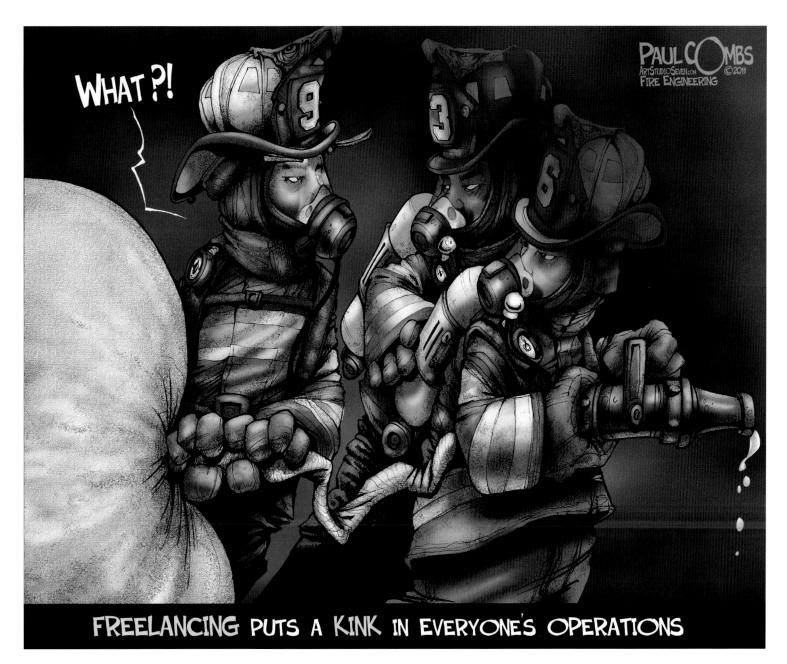

FREELANCING PUTS A KINK IN EVERYONE'S OPERATIONS

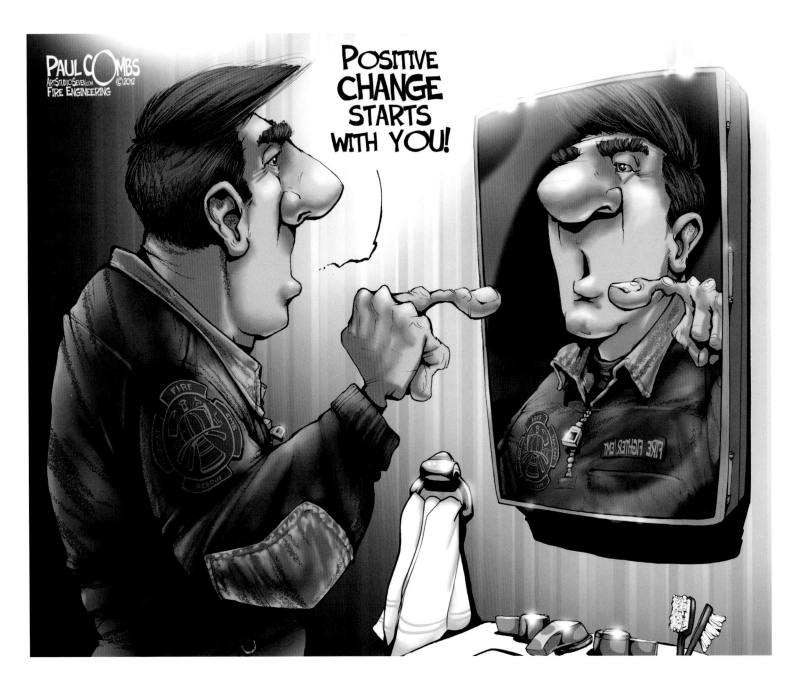

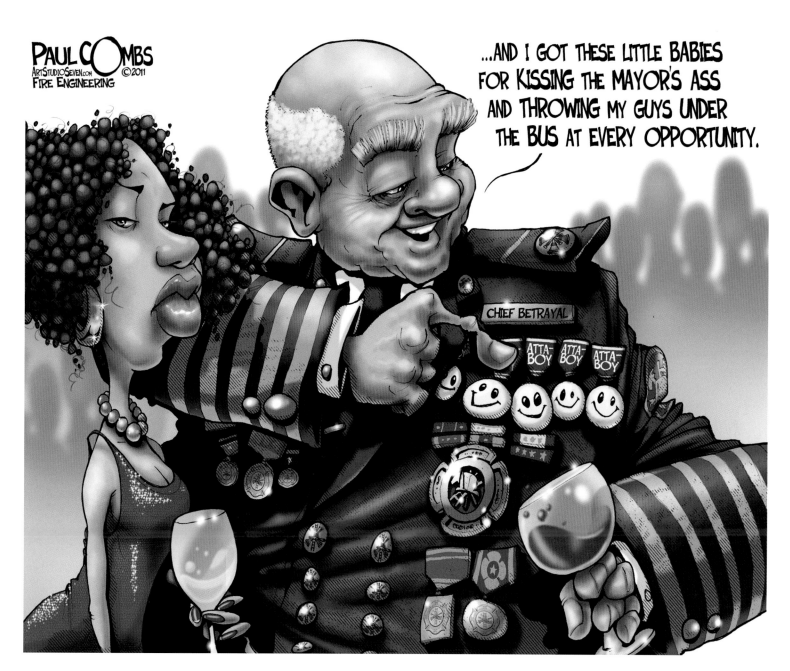

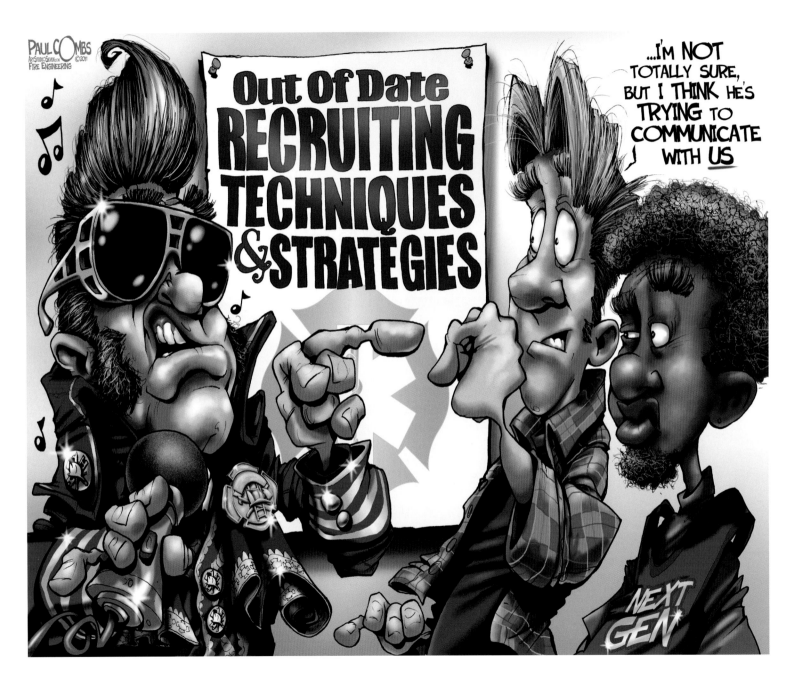

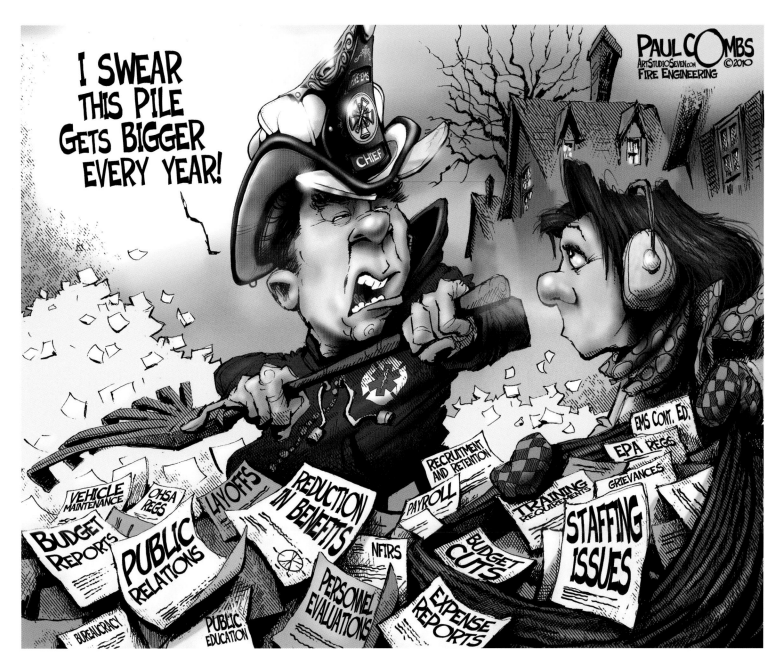

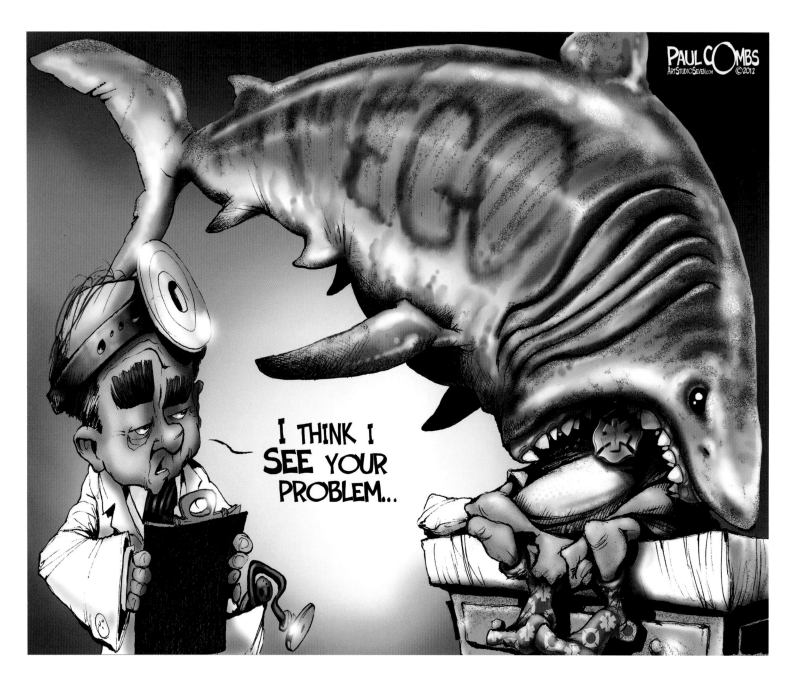

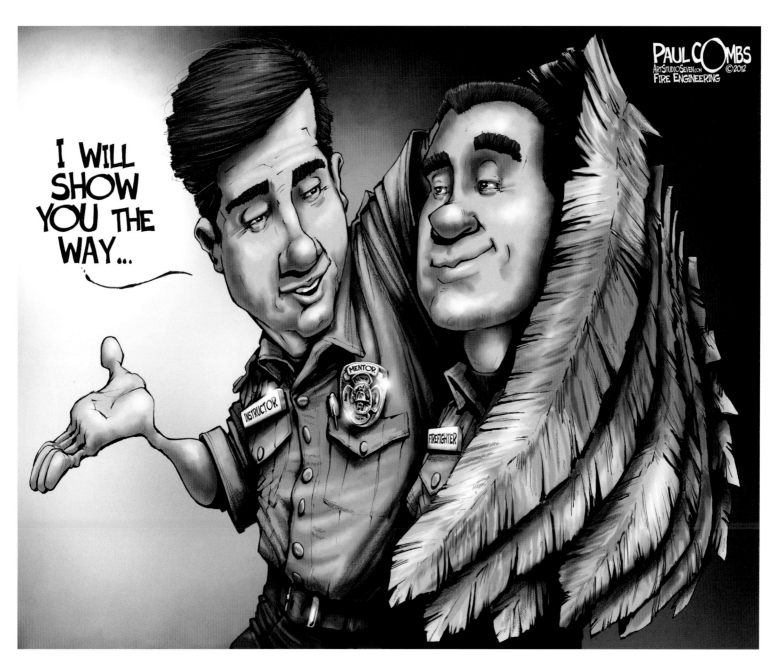

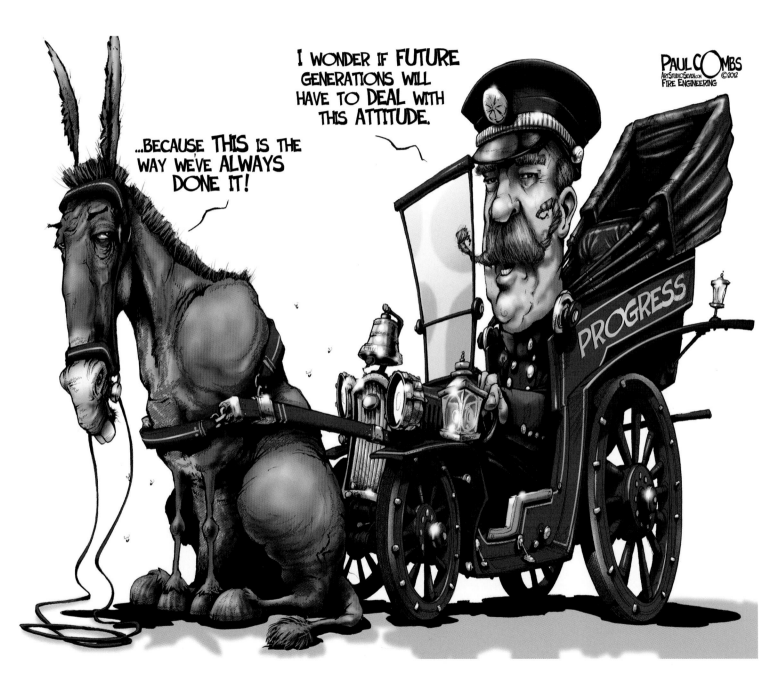

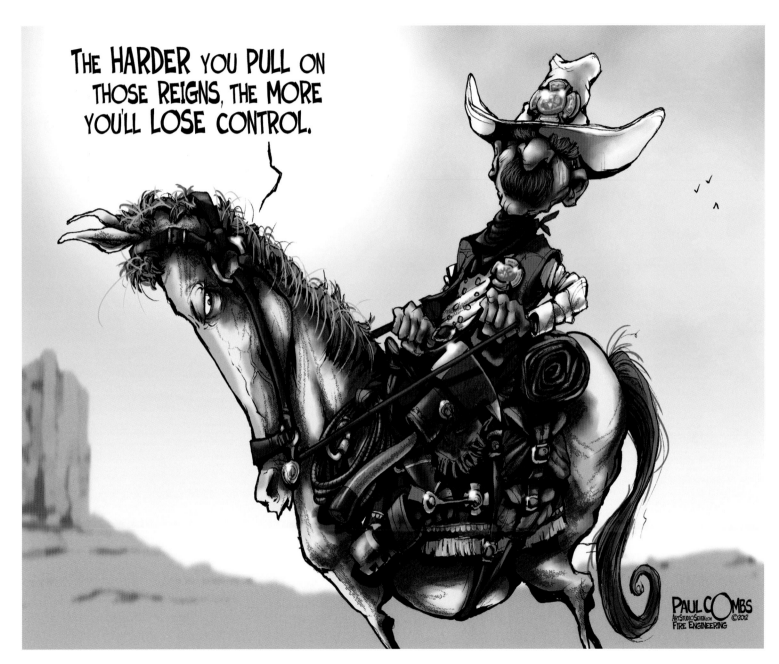

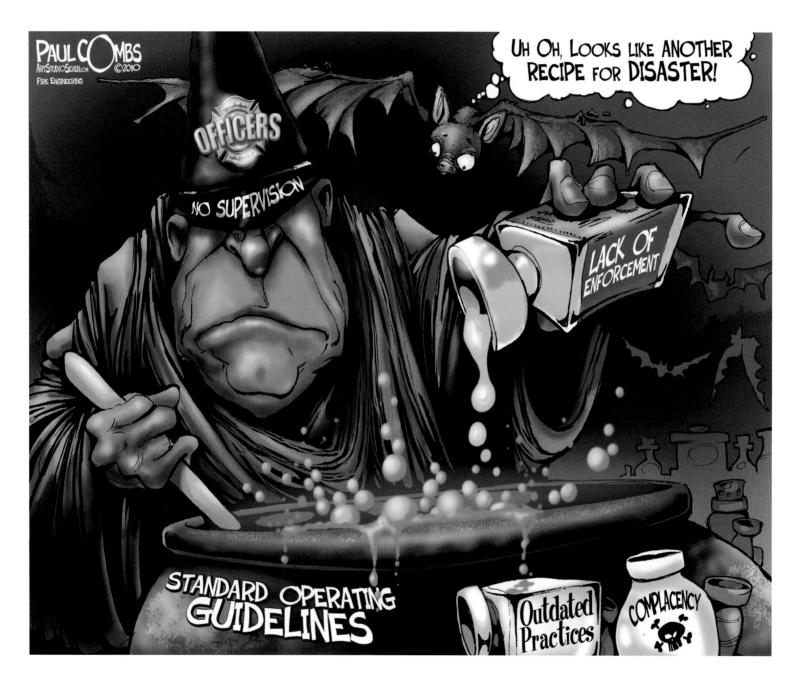

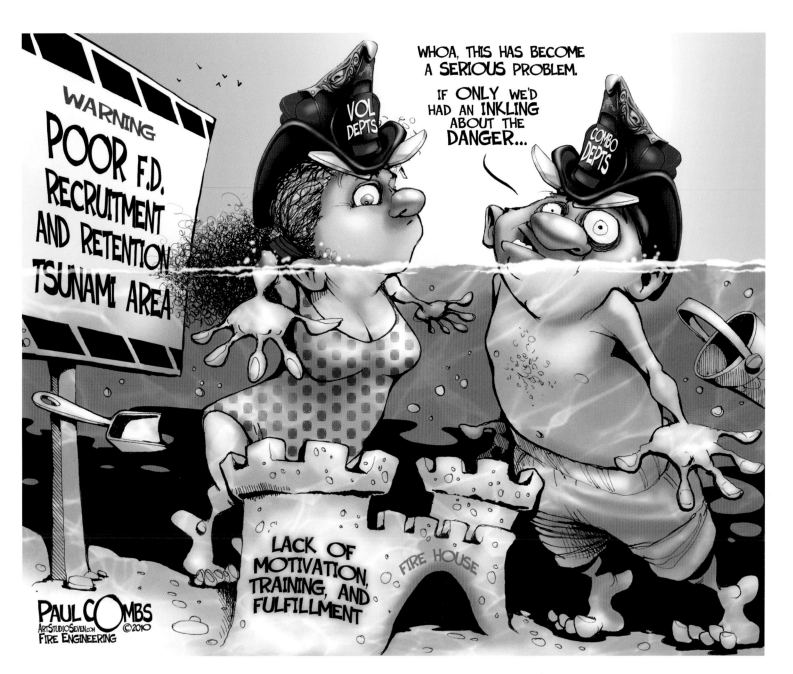

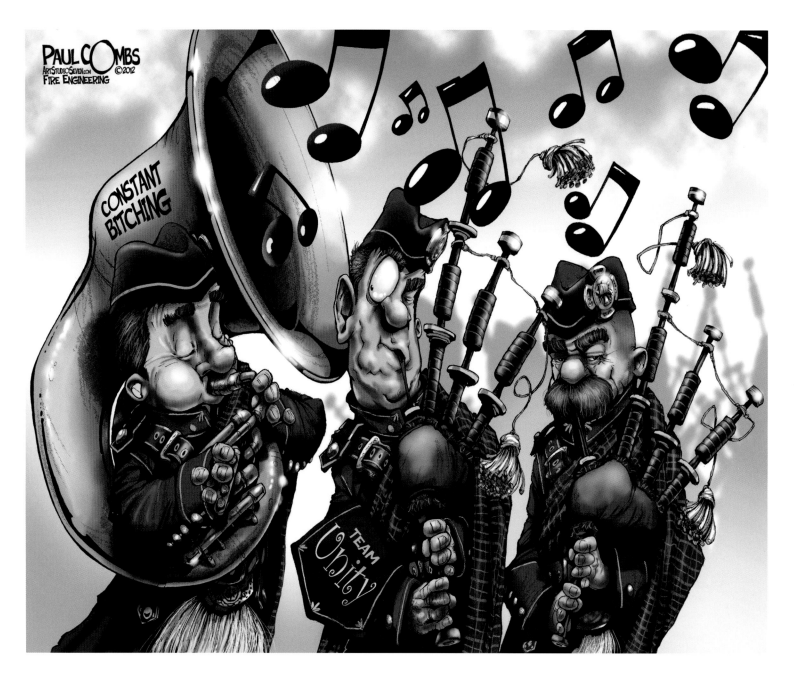

The Fire Line

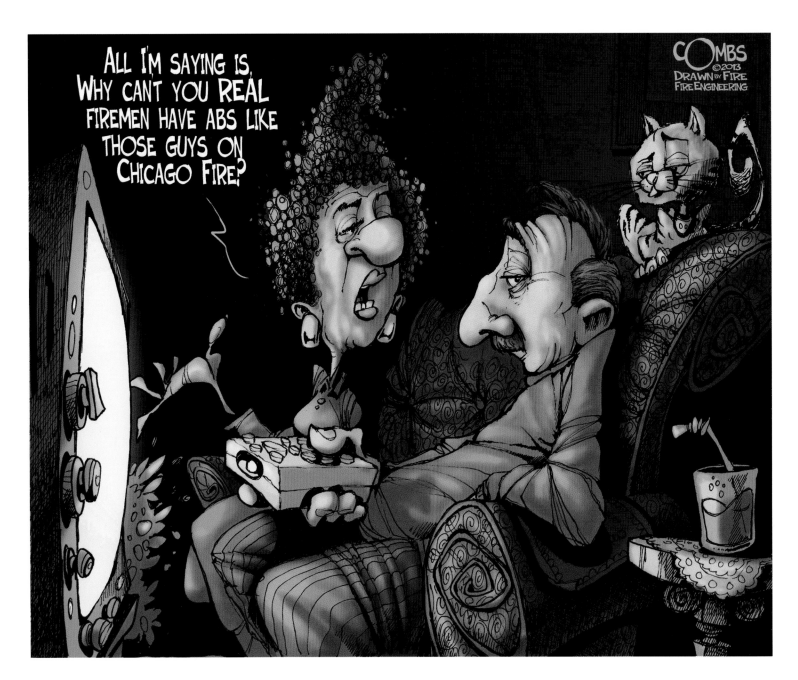

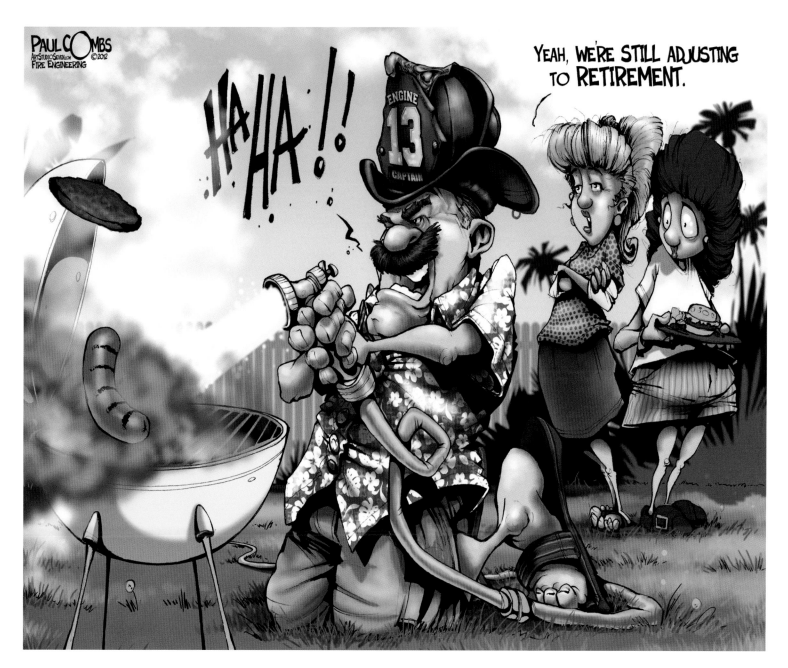

The Crazy Creative Process

The question I most often hear from fans is how my creative process works. My favorite answer is I drink copious amounts of espresso, put my pen on paper and see what happens. Well, that is somewhat true (the espresso part). In reality, the process is a little more thought out and technical, so I thought I'd share my process with you so you can get a glimpse into the madness that is a final cartoon.

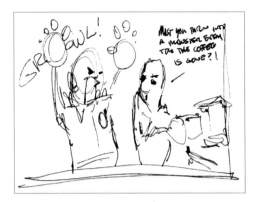

Every cartoon begins as a small 2"x2" thumbnail sketch in my idea book. This little book accompanies me almost everywhere (except the shower) because I just never know when and where a good idea is going to strike – and far too many great cartoons have been lost to the black-whole that is my memory.

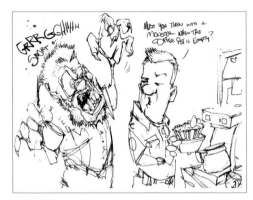

From rough thumbnail, the idea becomes an 8"x10" rough sketch. Here the characters begin to take form and gestures are explored. The process begins as pencil circles and lines, and develops into an inked sketch that becomes a guide for the final artwork.

I place the rough inked sketch under a larger piece of Strathmore drawing paper, then place on my light table to expose the rough sketch underneath. I begin with a pencil drawing to create the lines that will be inked – this becomes the finished drawing.

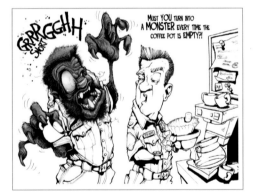

The finished drawing is scanned into PhotoShop where the painting process begins. I use a Wacom Cintiq to do the actual brush work, which can best be described as an amazing piece of technology that mimics a drawing surface where tiny, tiny digital elves run amuck spreading pixy dust to render what my crazy brain dreams up. Don't laugh; I've seen them… really!

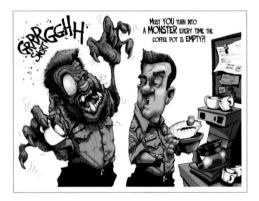

Finally, with the foreground painted, I focus on a background image or color scheme and finish rendering any details to enhance the overall look and message.

Voila, a cartoon is born.

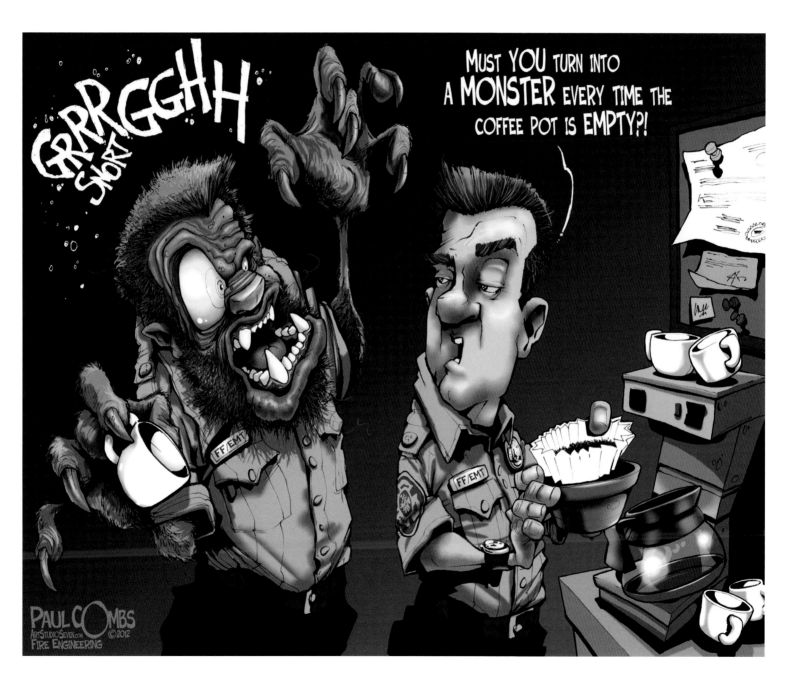

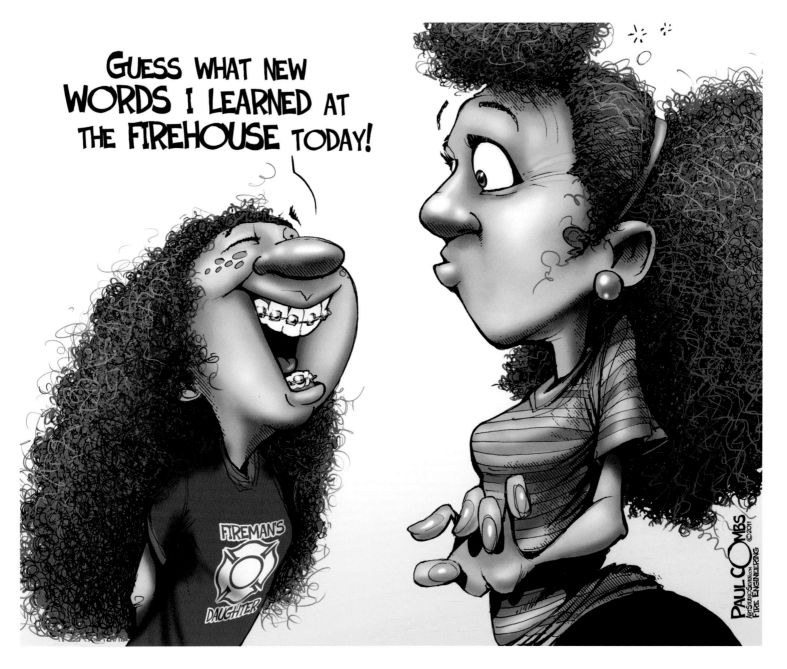

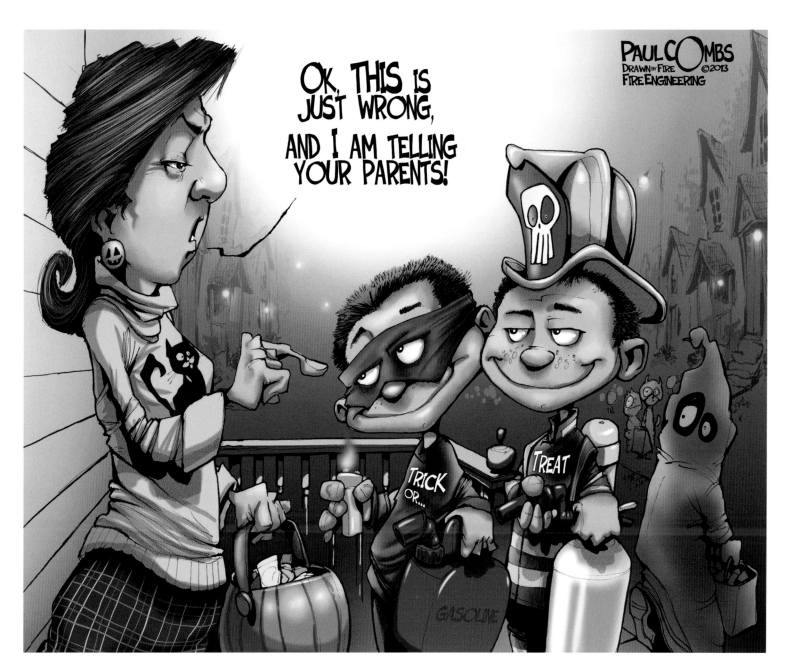

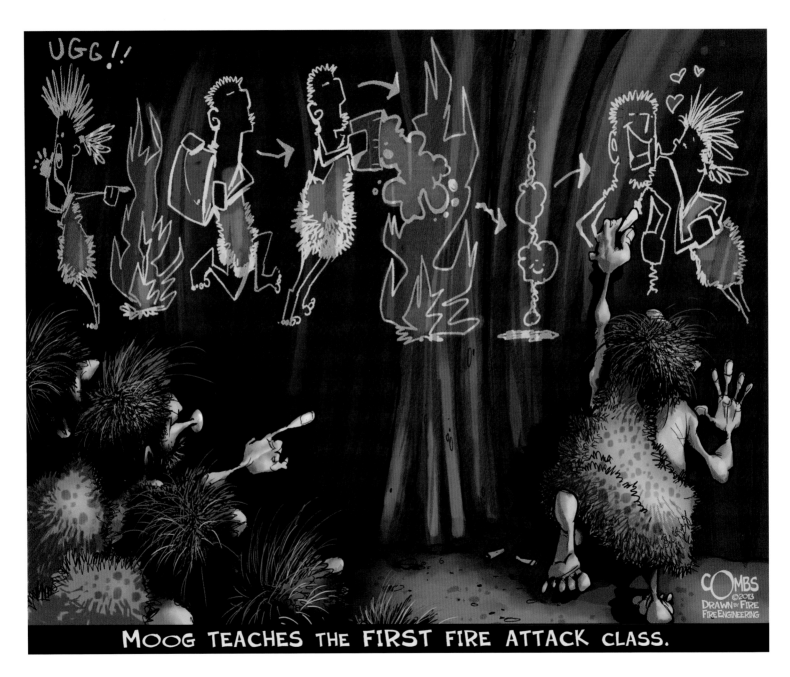

MOOG TEACHES THE FIRST FIRE ATTACK CLASS.

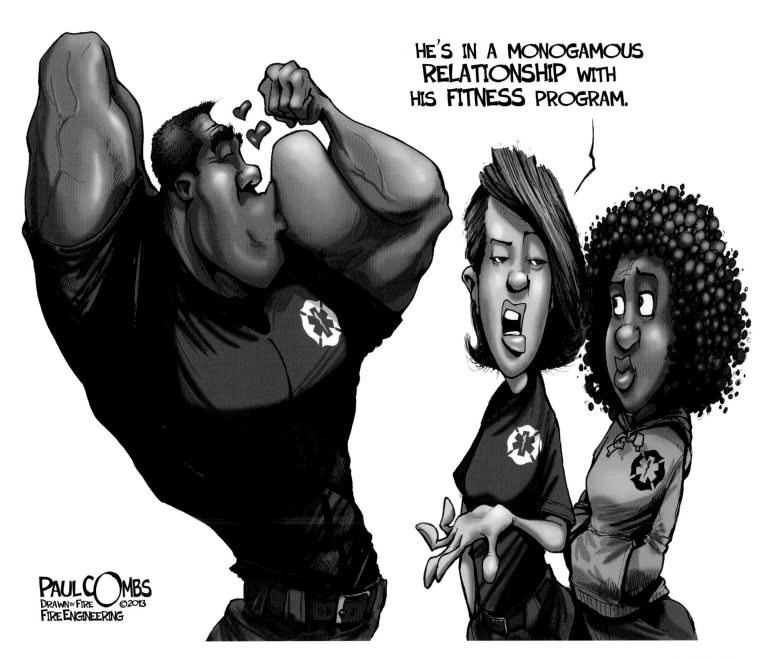

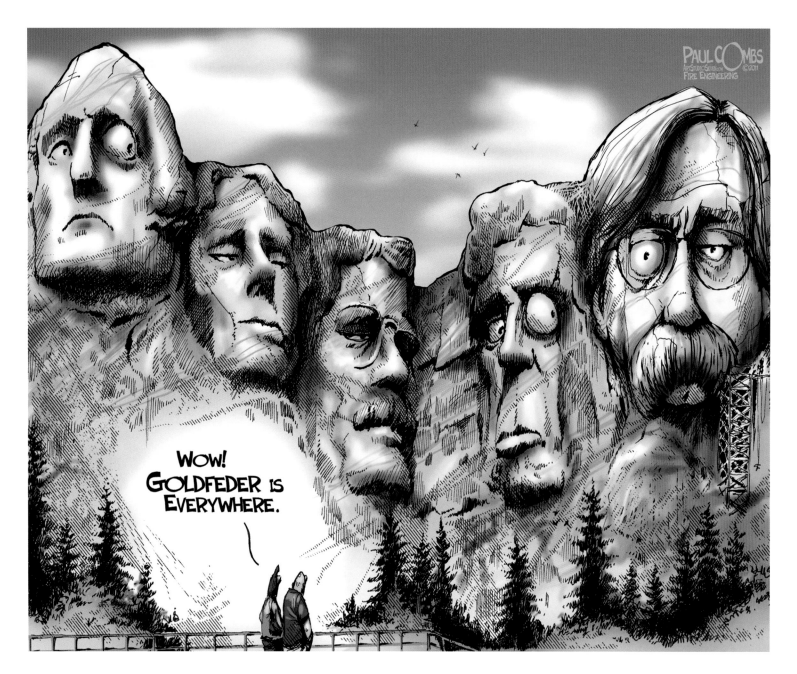

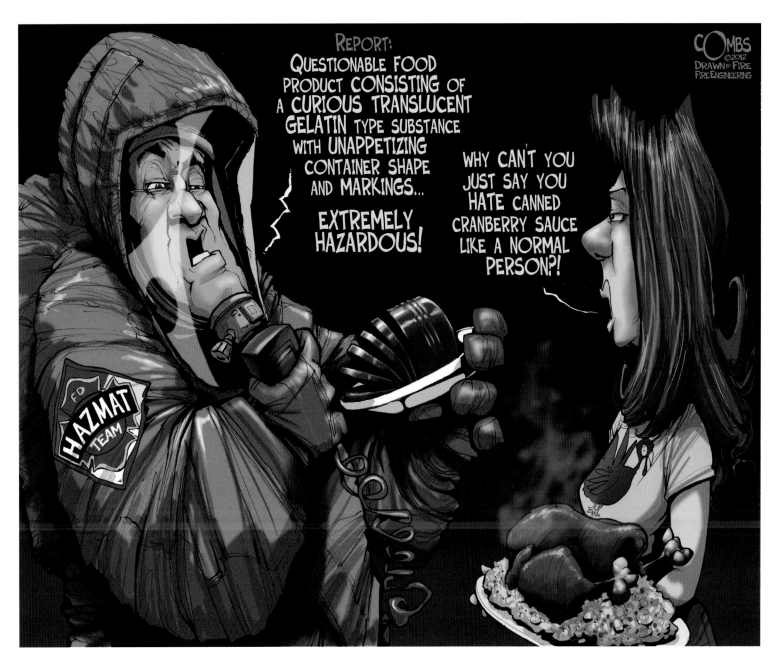

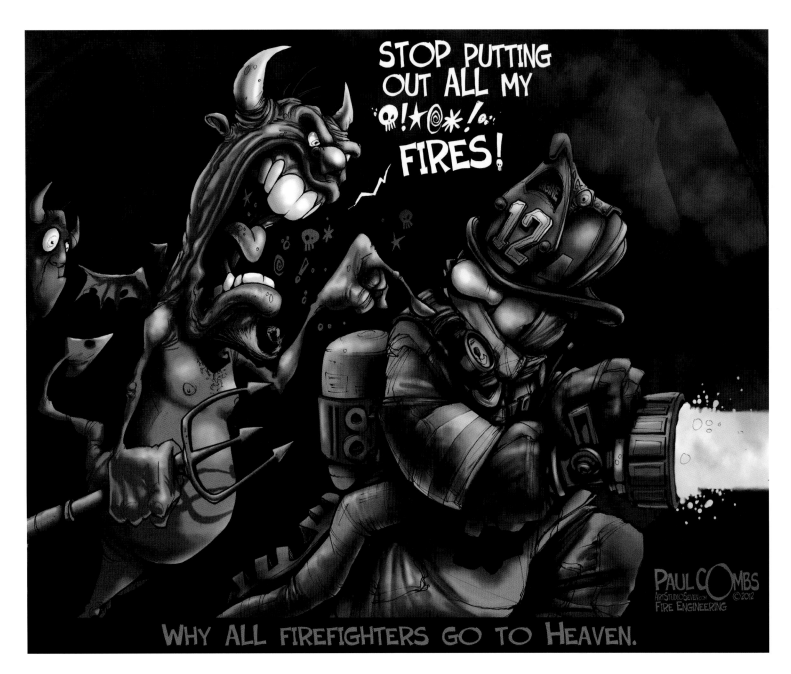

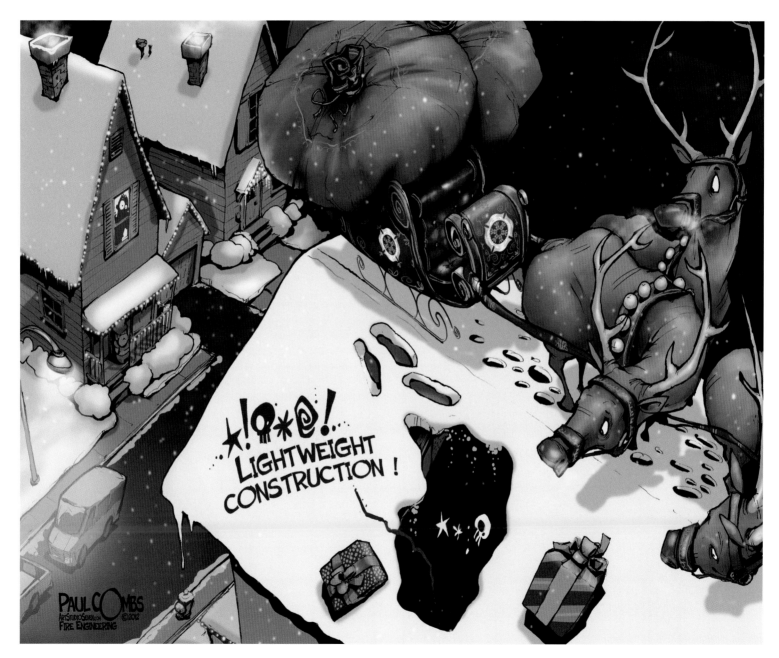

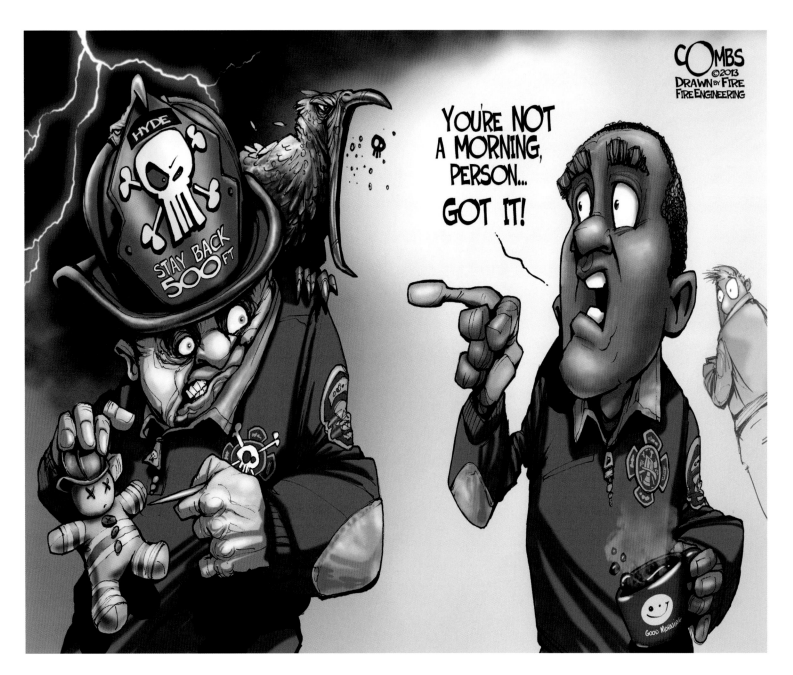

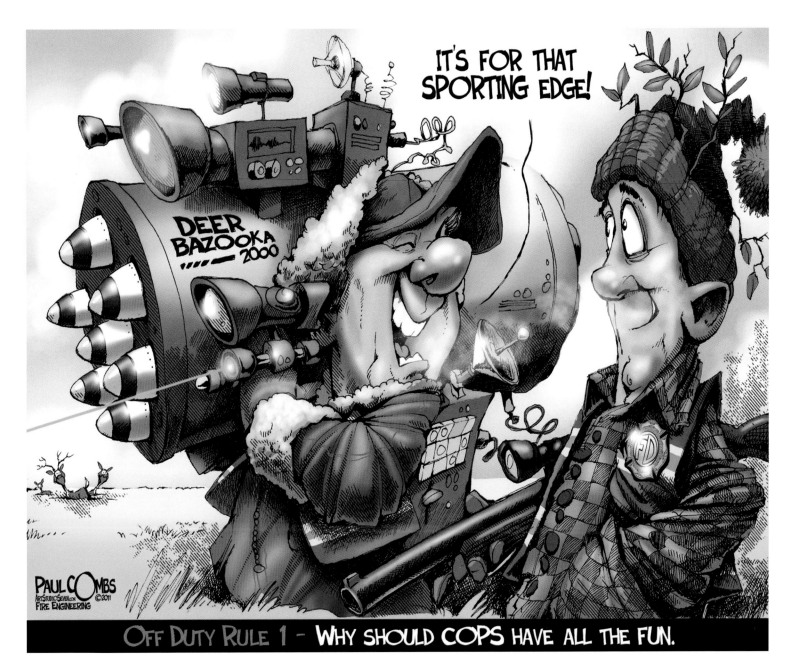

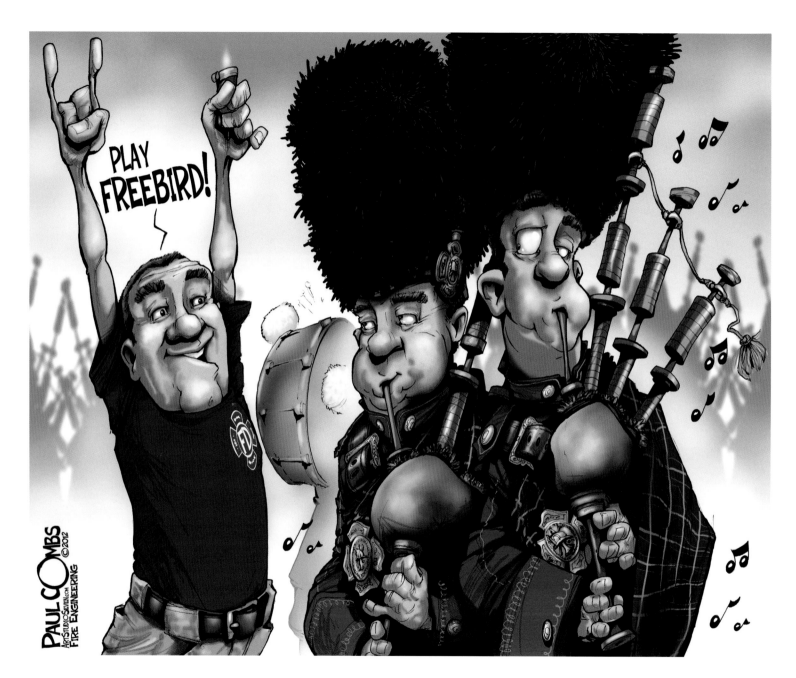

PLAY FREEBIRD!

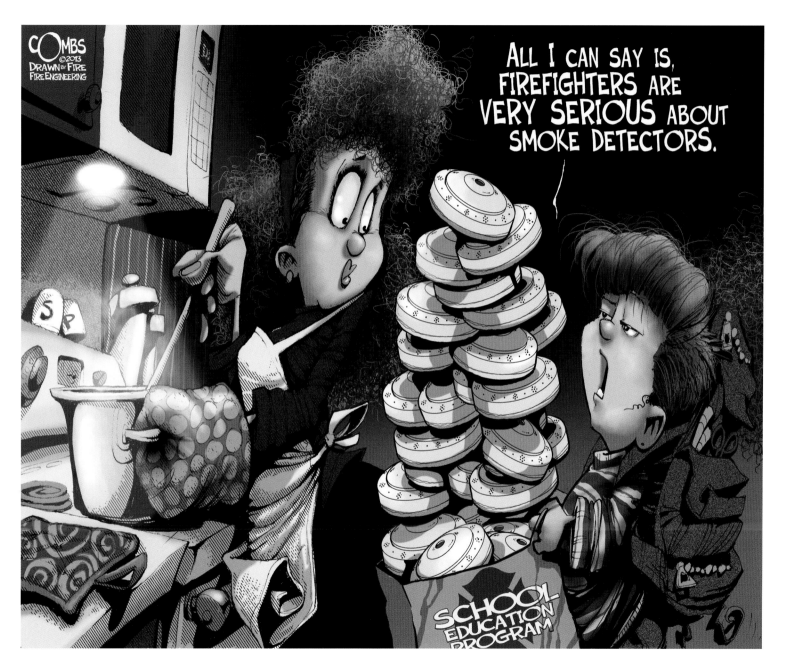

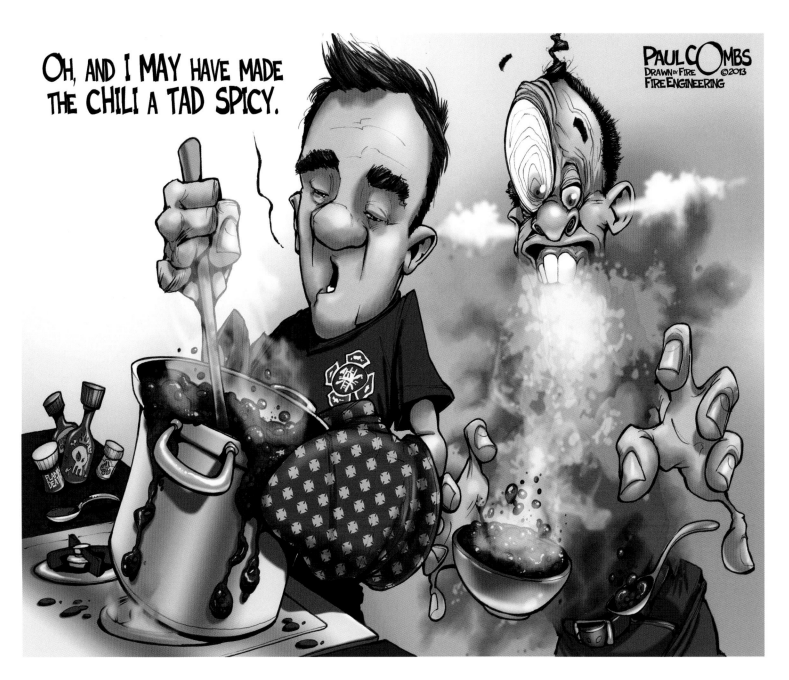

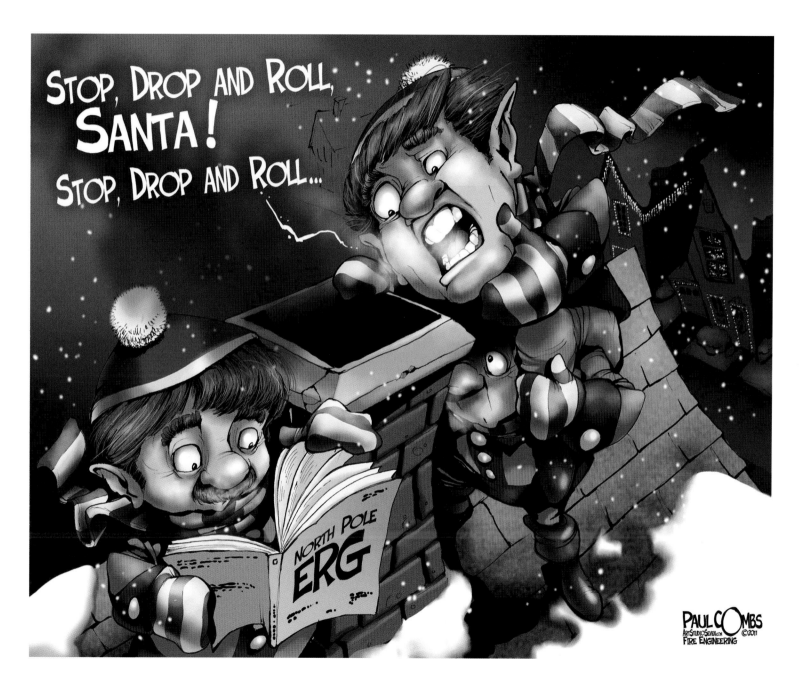

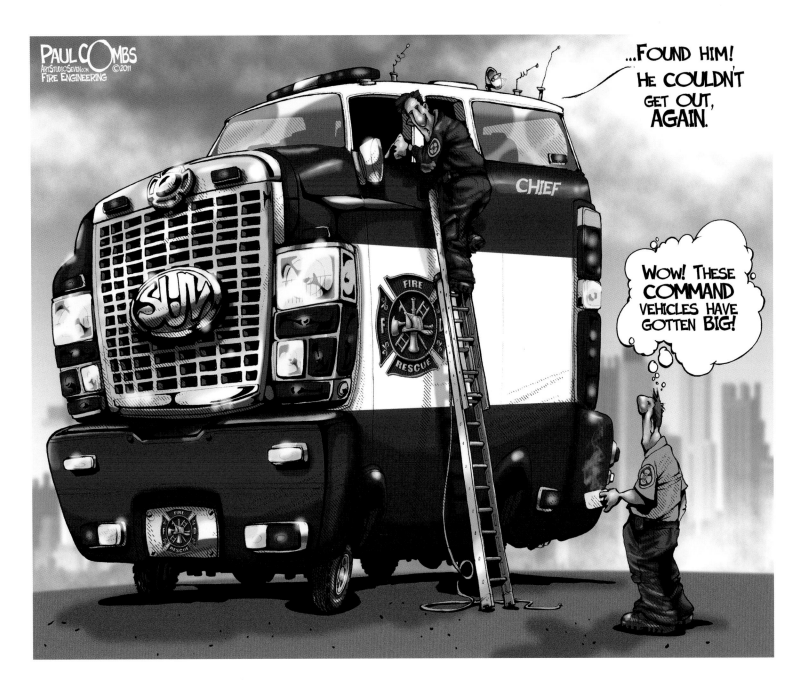

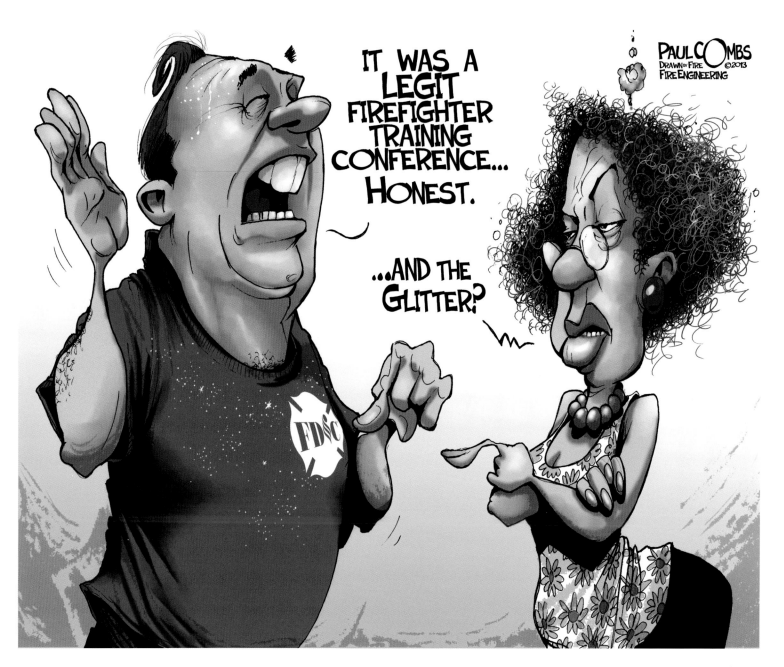

WHY HOLLYWOOD CAN'T MAKE REALISTIC FIREFIGHTER MOVIES.

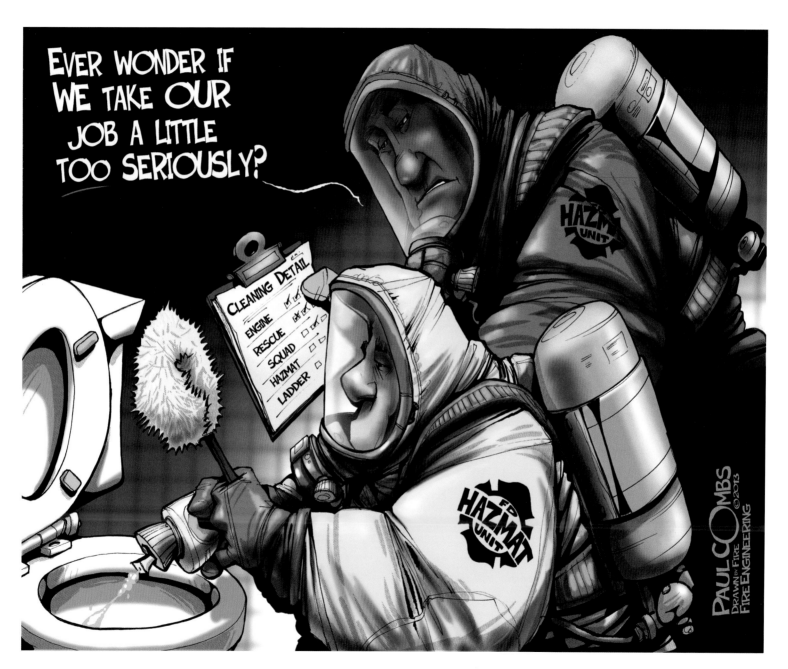

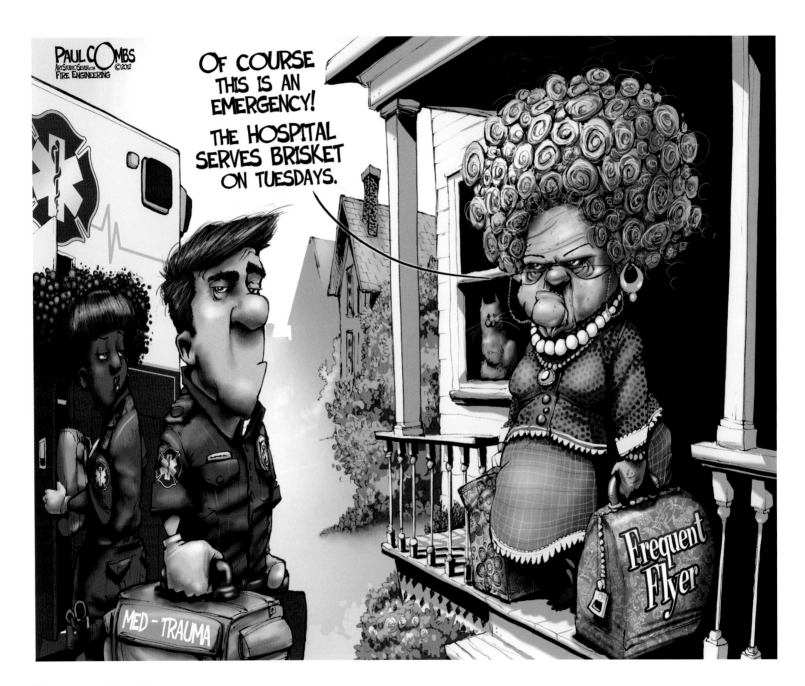

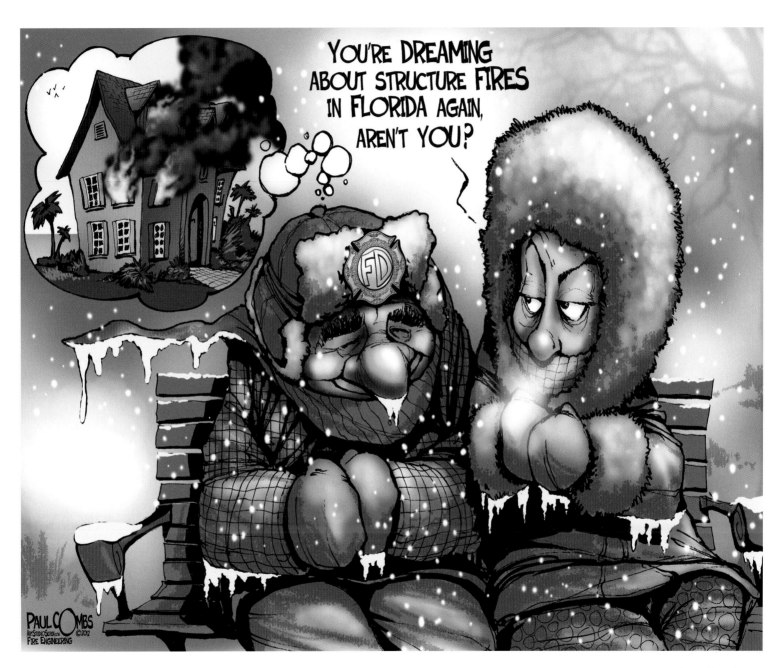

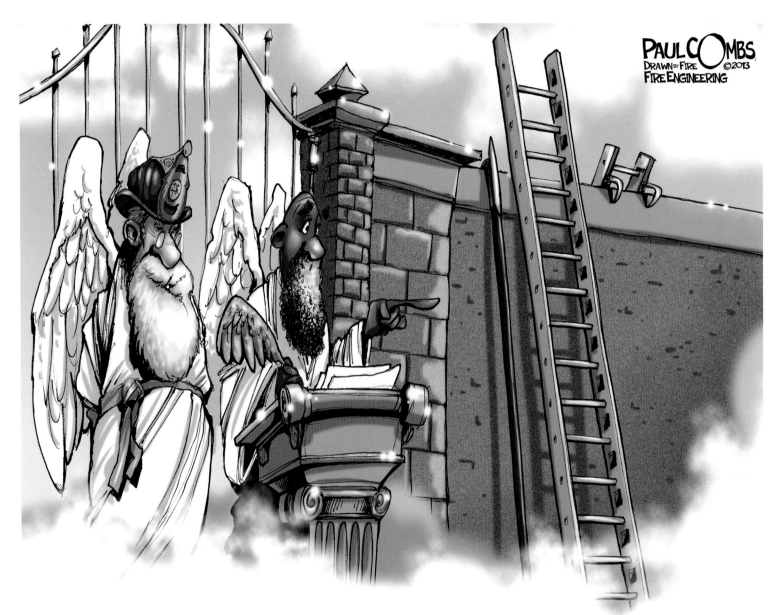

TRUCKIES JUST CAN'T ENTER HEAVEN LIKE EVERYONE ELSE.

The Political Guillotine

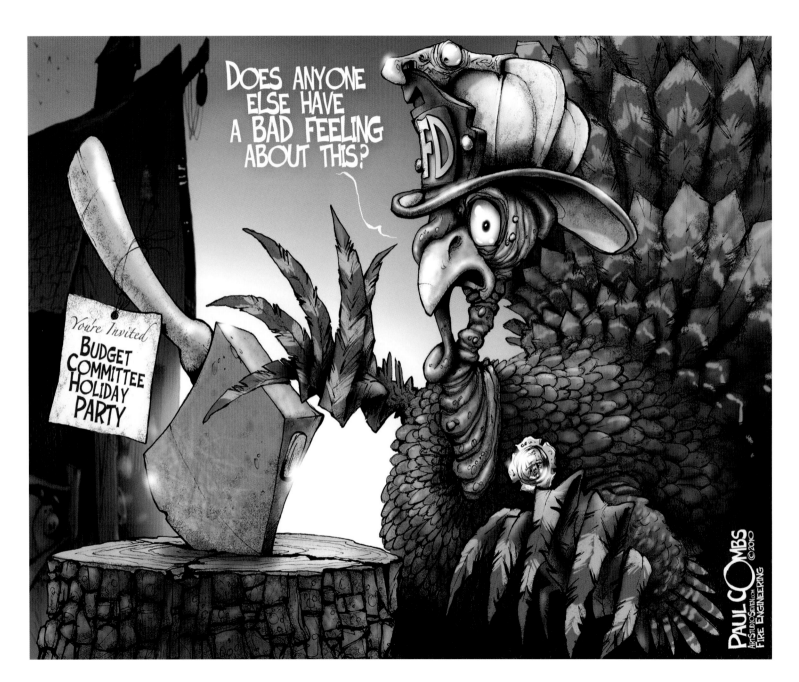

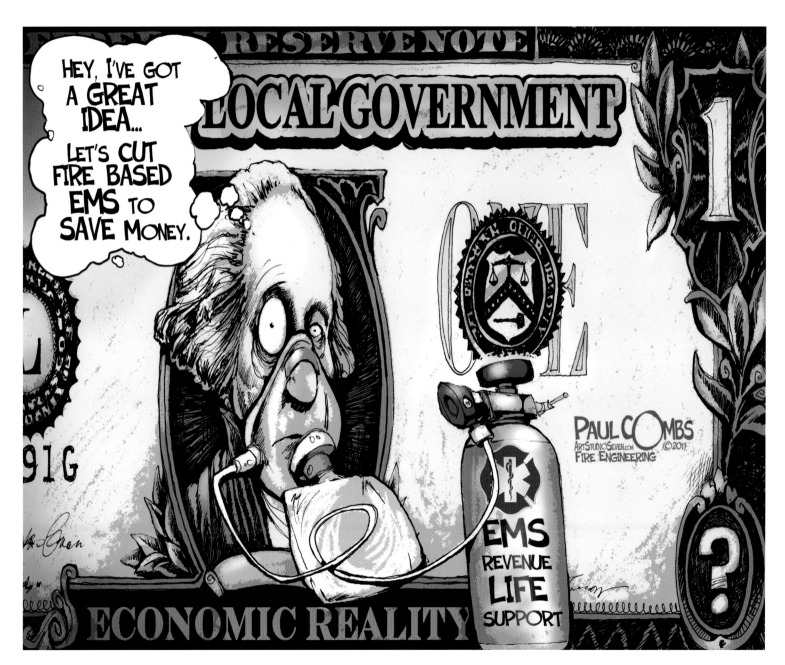

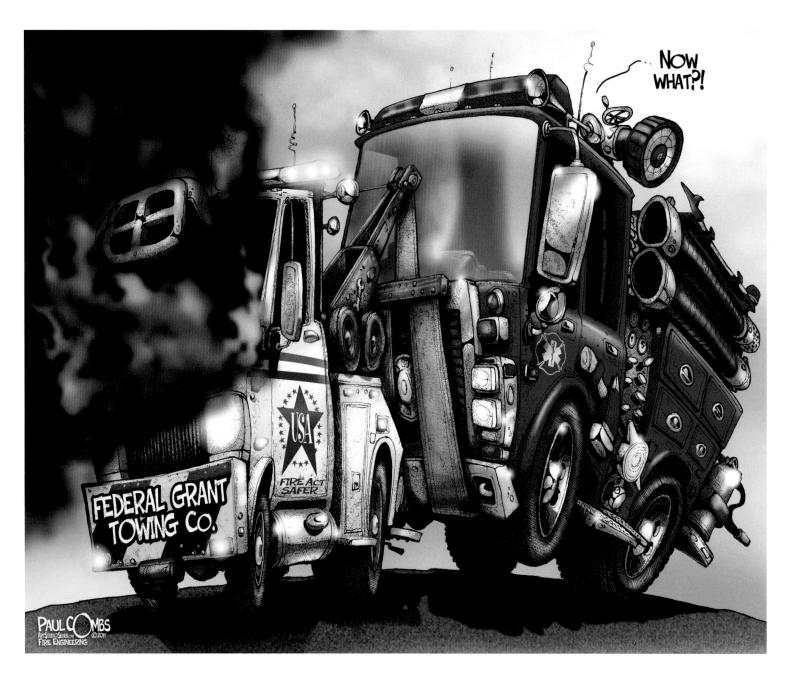

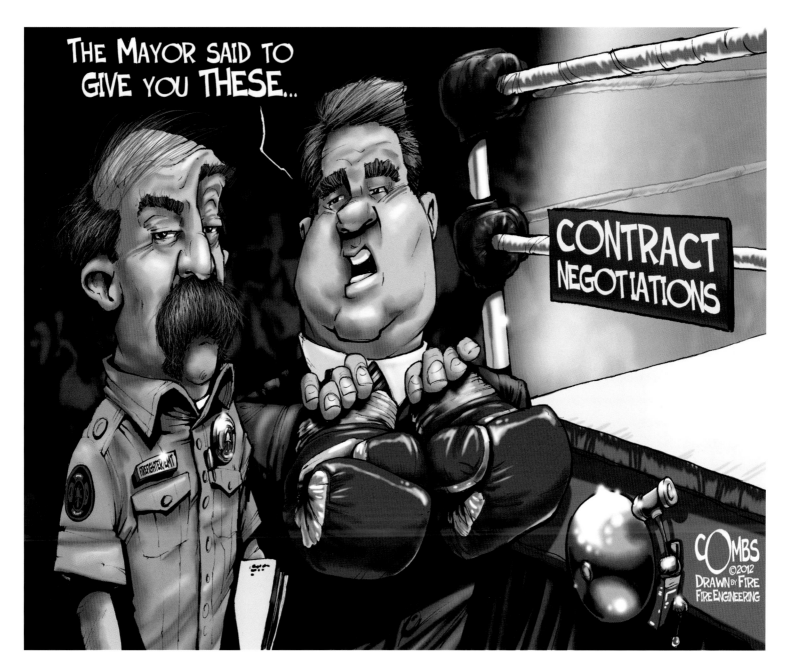

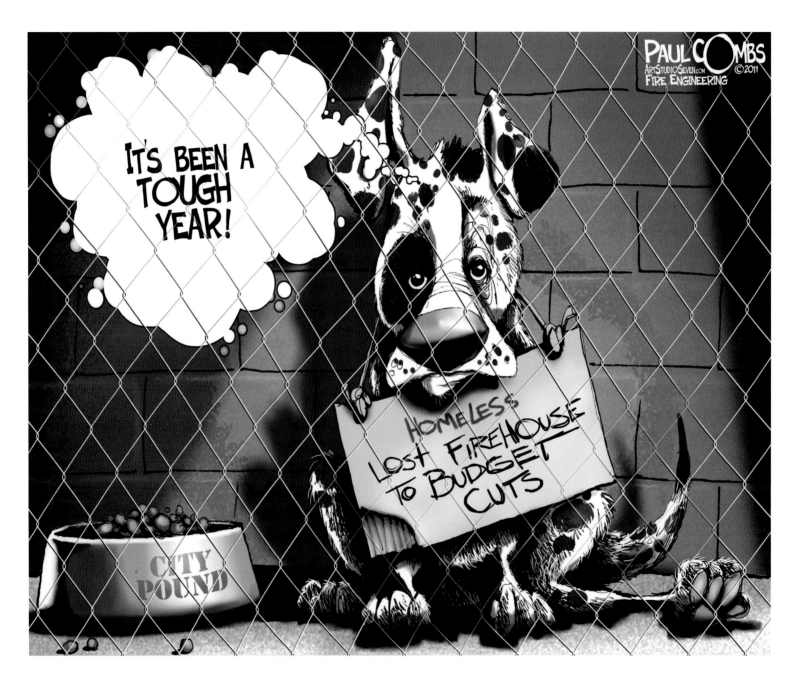

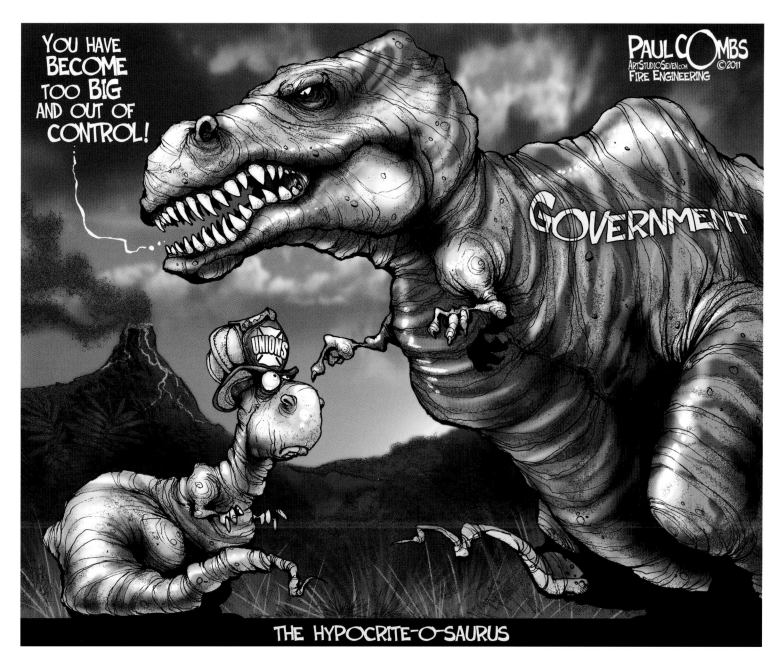

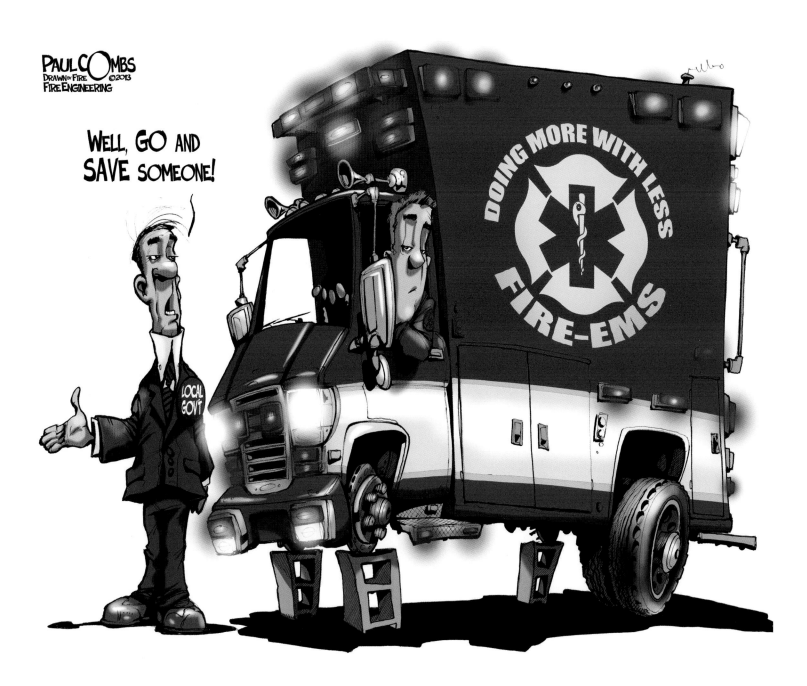

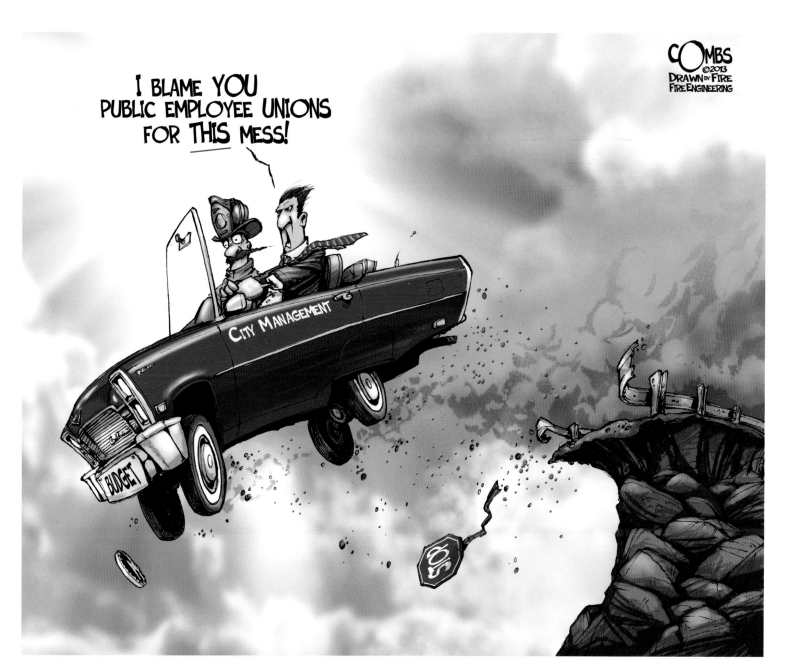

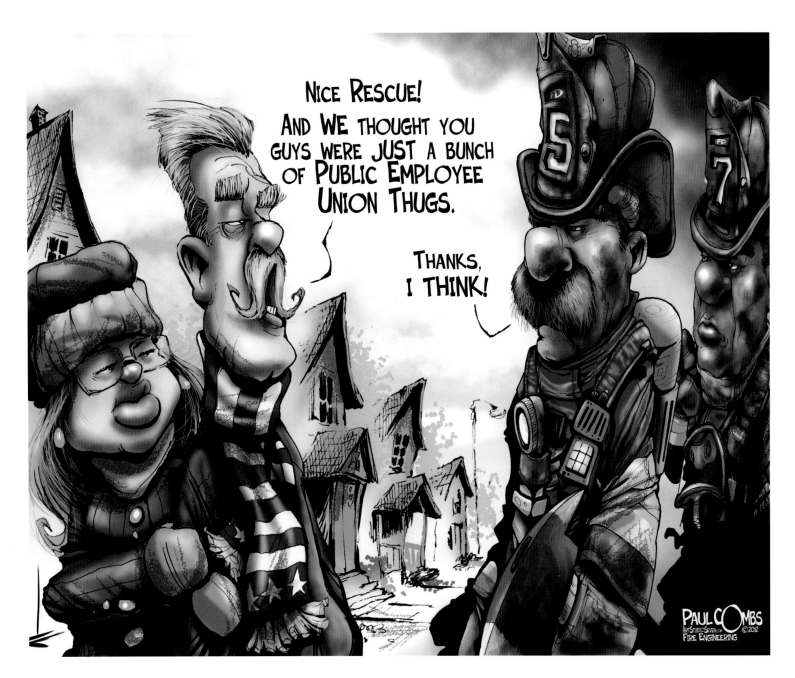

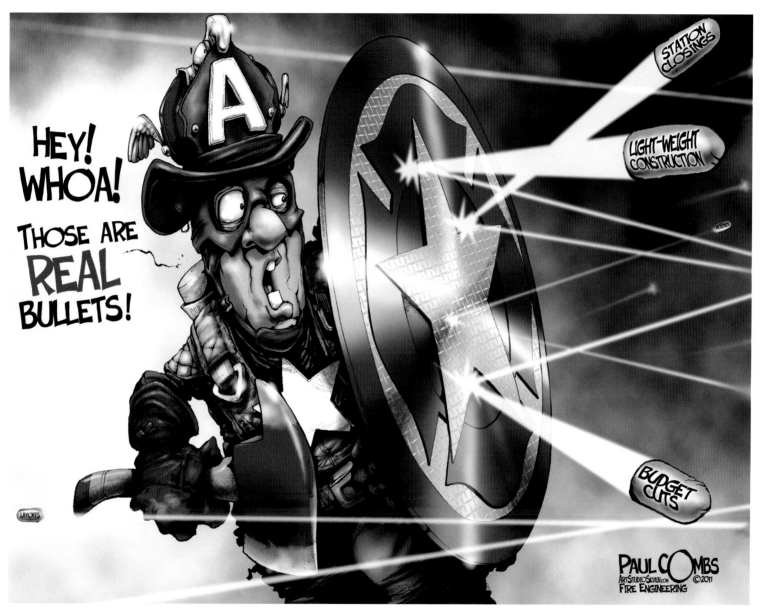

THE REAL ATTACK ON A REAL AMERICAN HERO!

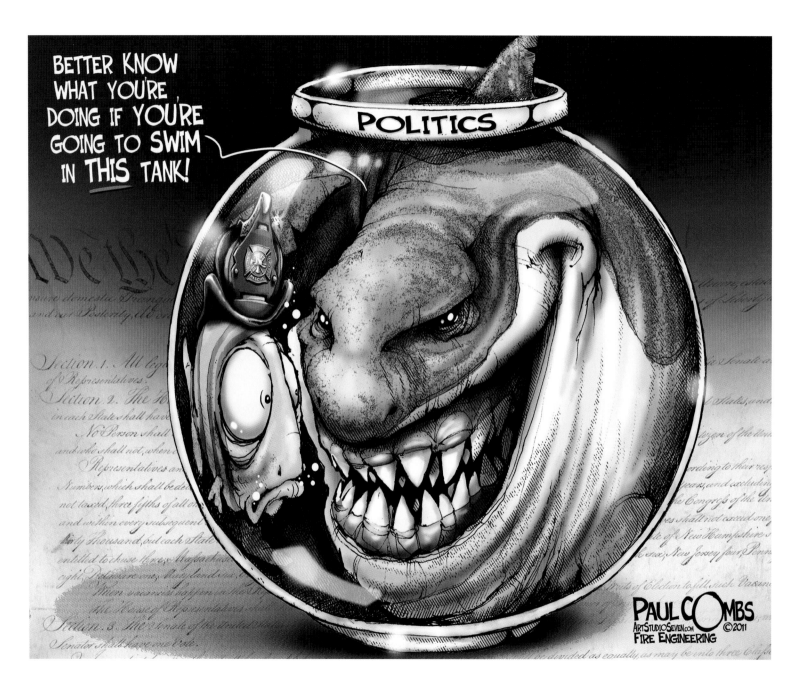

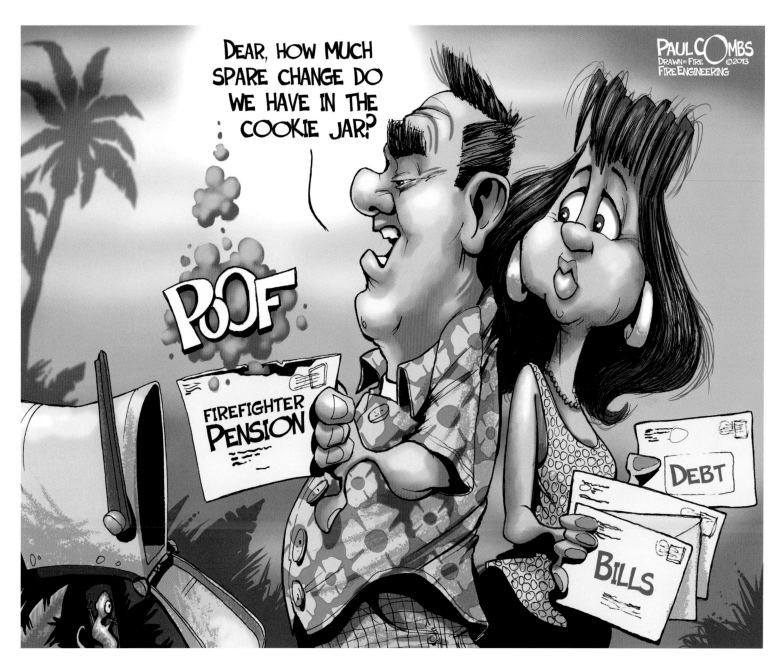

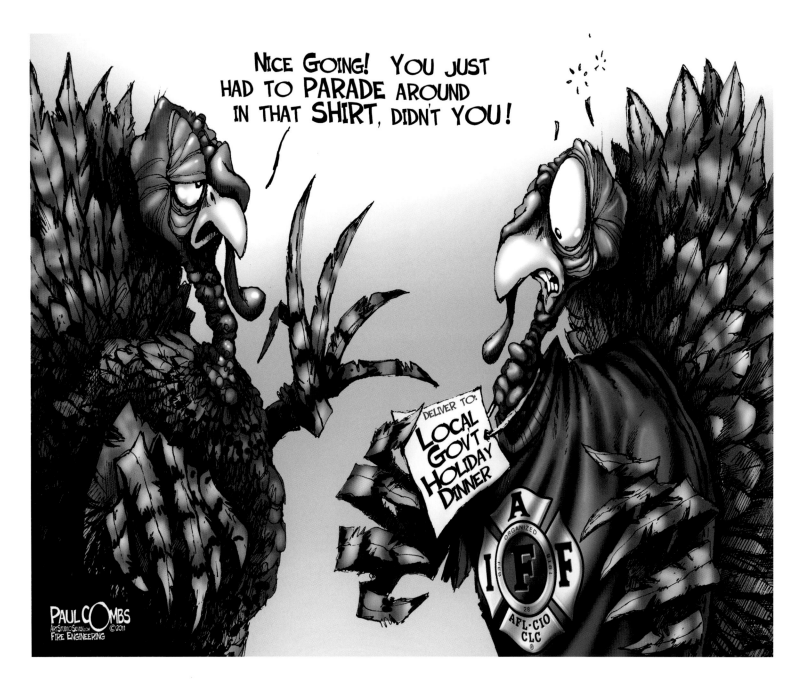

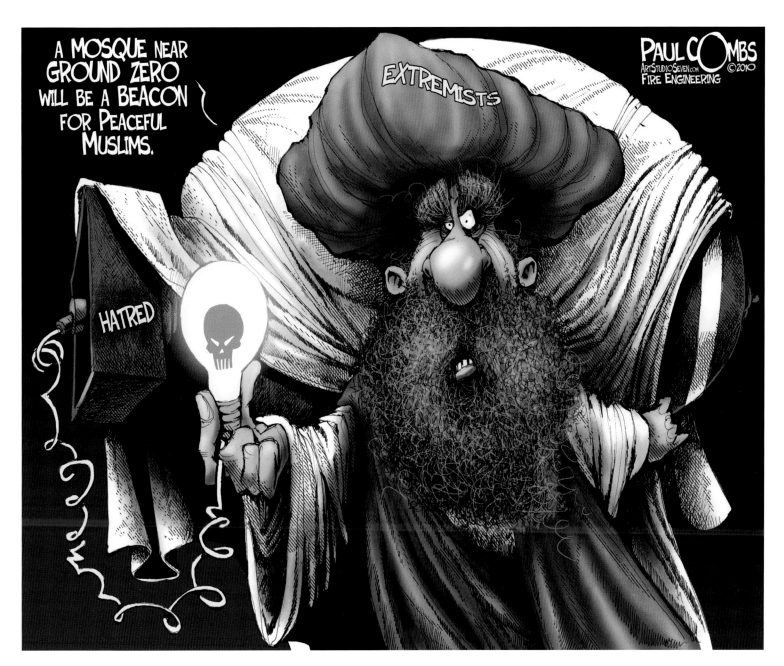

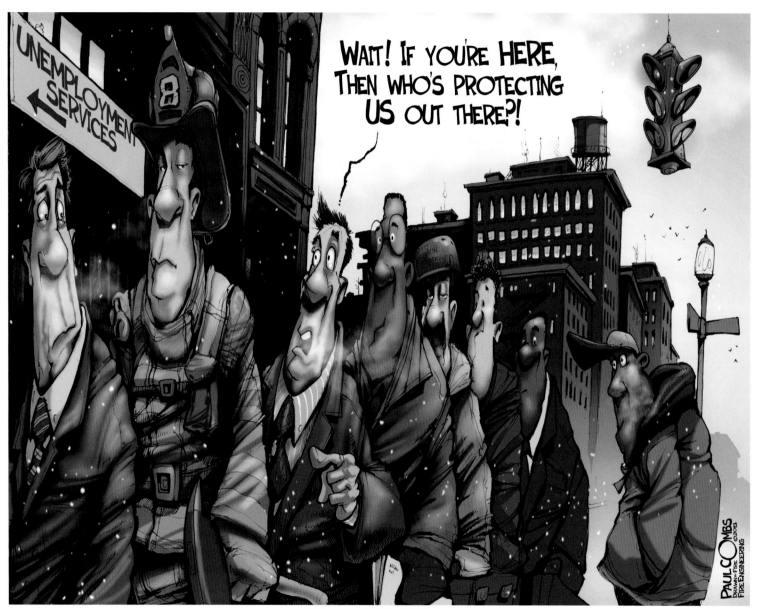

THE EPIPHANY

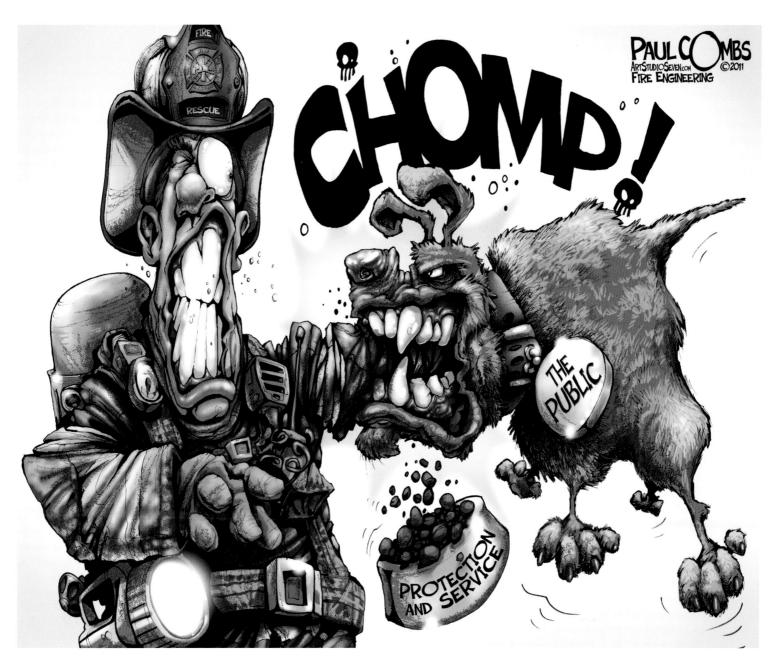

WHAT A
FIREFIGHTER
IS WORTH
DURING AN
ELECTION
CAMPAIGN.

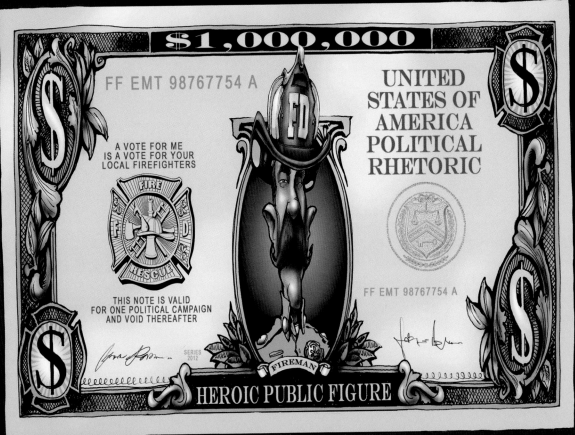

WHAT A FIREFIGHTER IS WORTH
AFTER AN ELECTION CAMPAIGN.

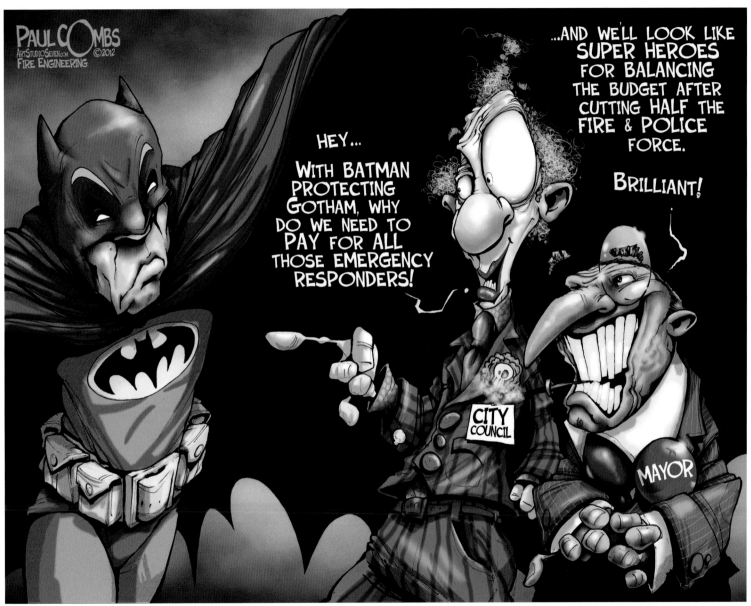

THE PLAUSIBLE HOLLYWOOD VILLAINOUS PLOT

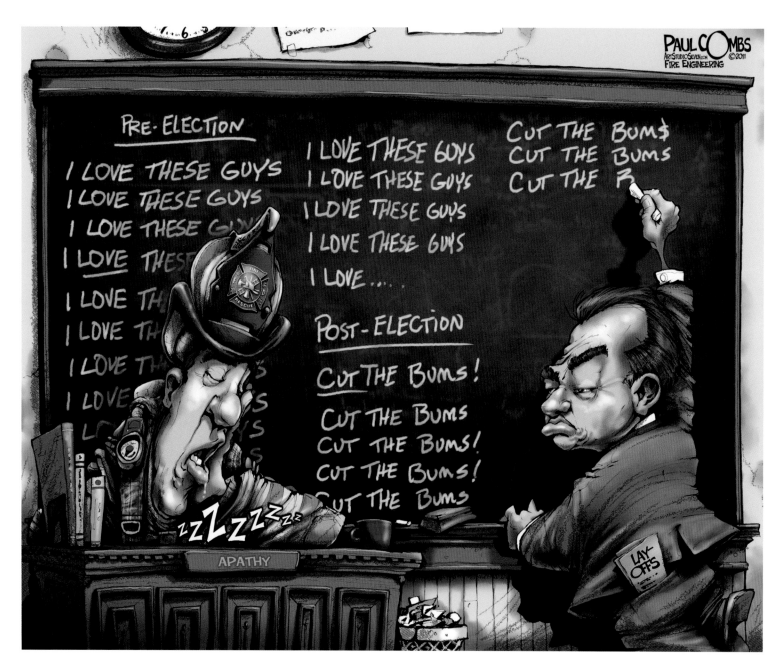

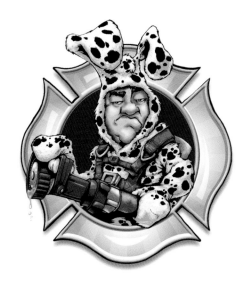

Potty Training

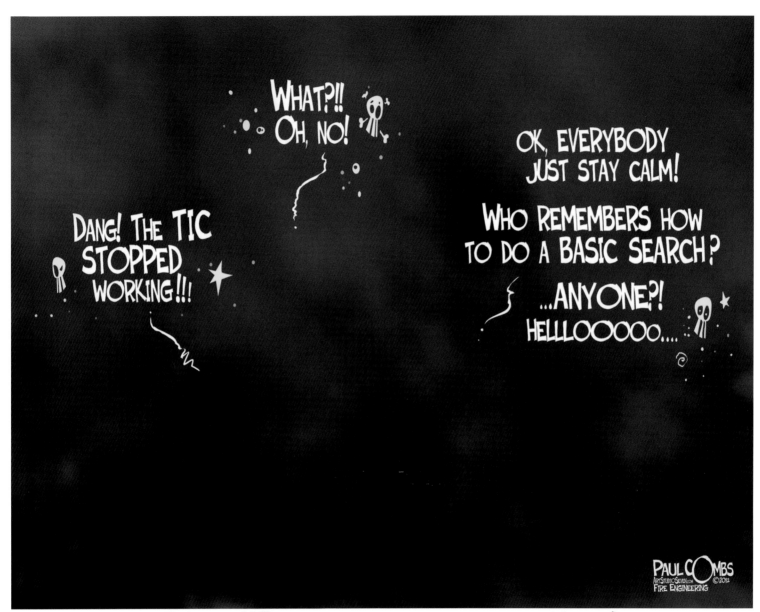

THERE IS NO SUBSTITUTE FOR KNOWING THE BASICS!

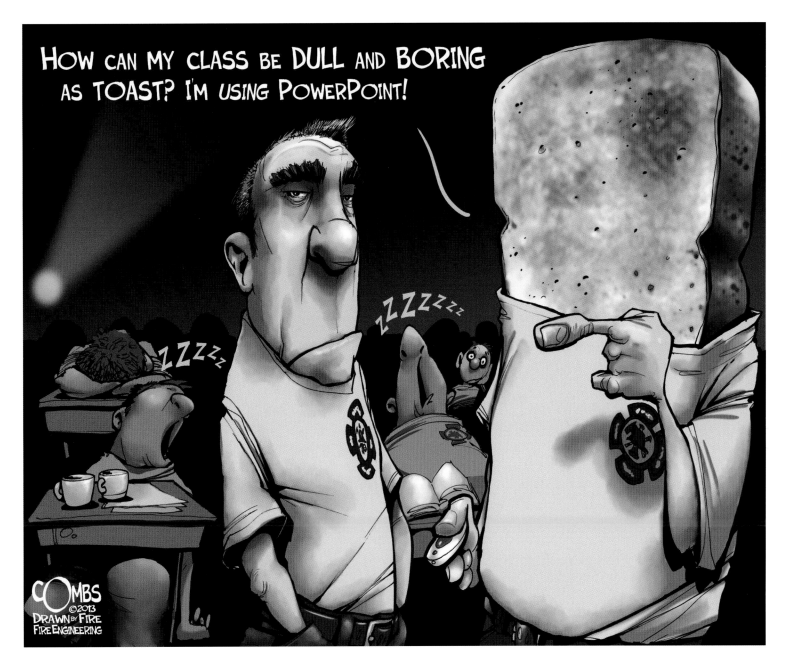

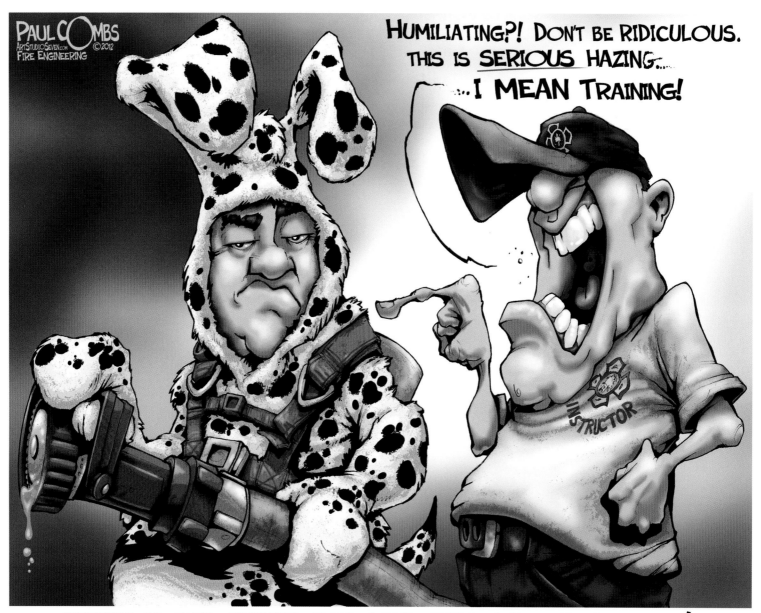

TRAINING IS FOR TRAINING, NOT YOUR AMUSEMENT - KEEP IT REAL!

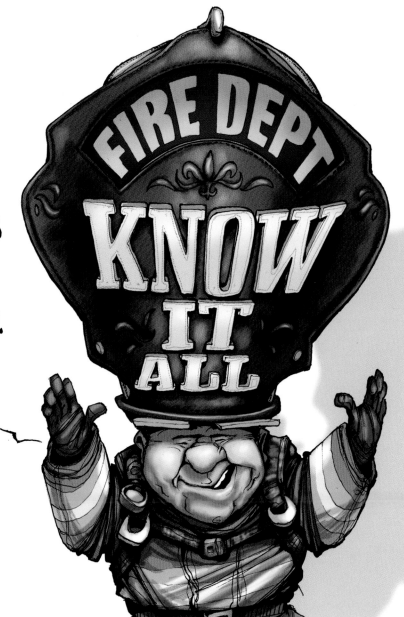

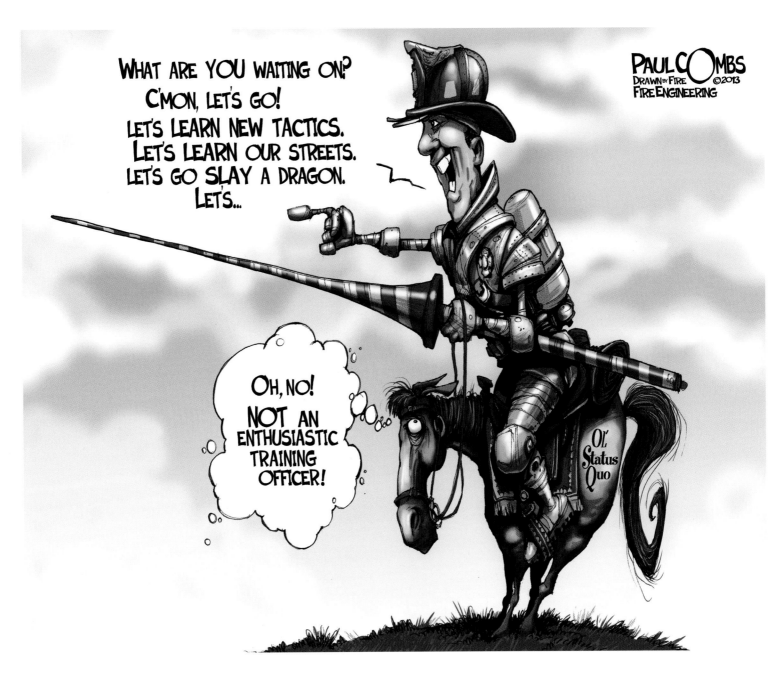

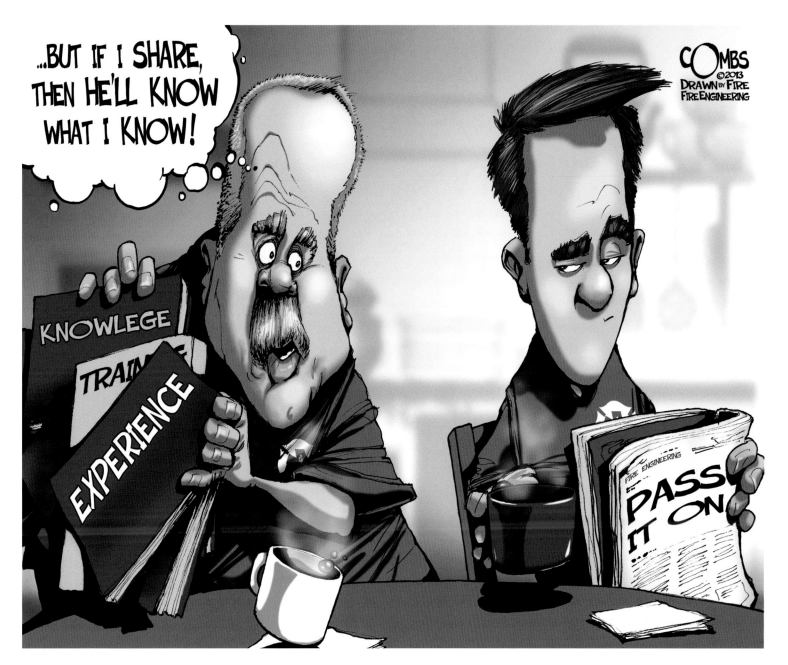

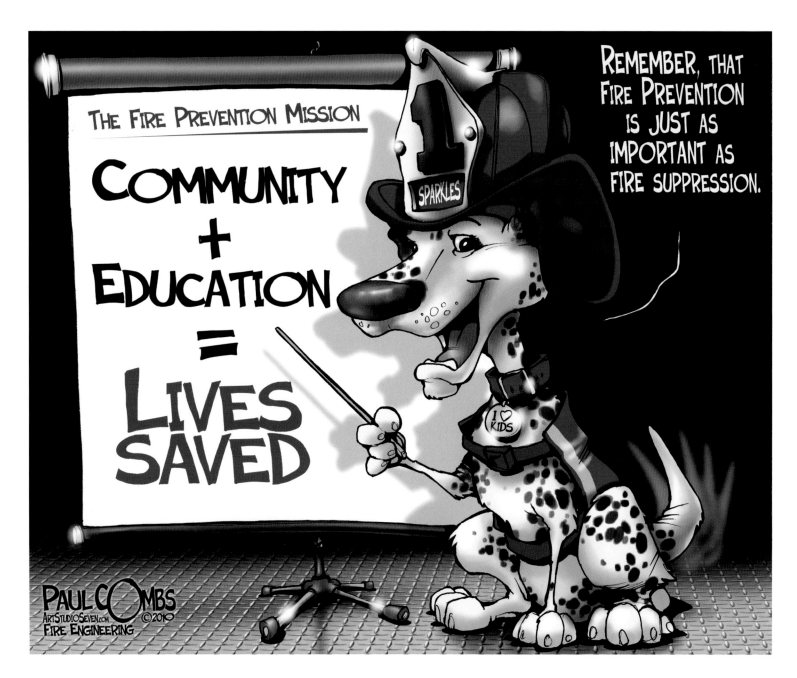

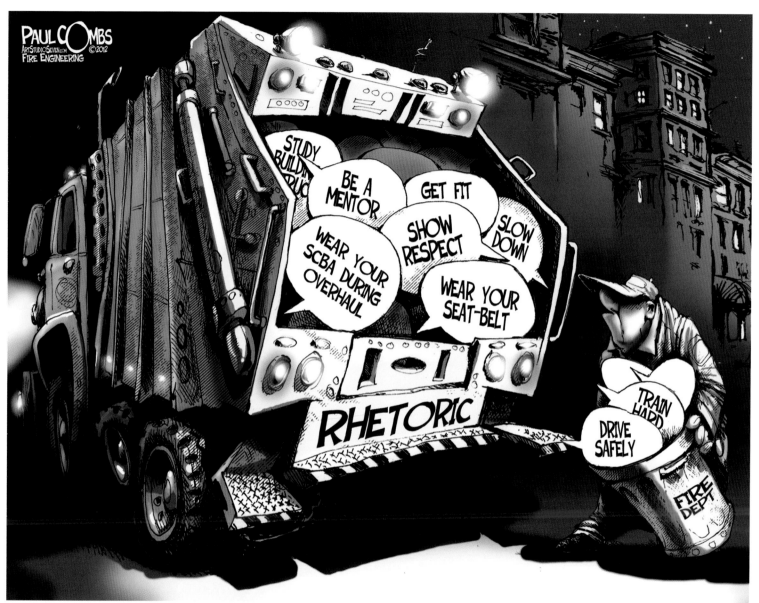

"WISH THESE GUYS WOULD PRACTICE WHAT THEY PREACH."

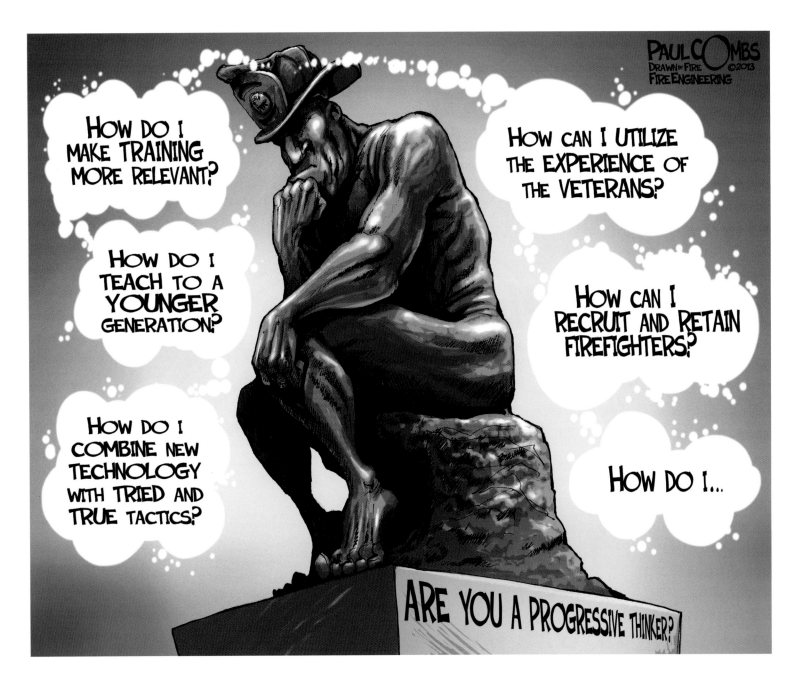

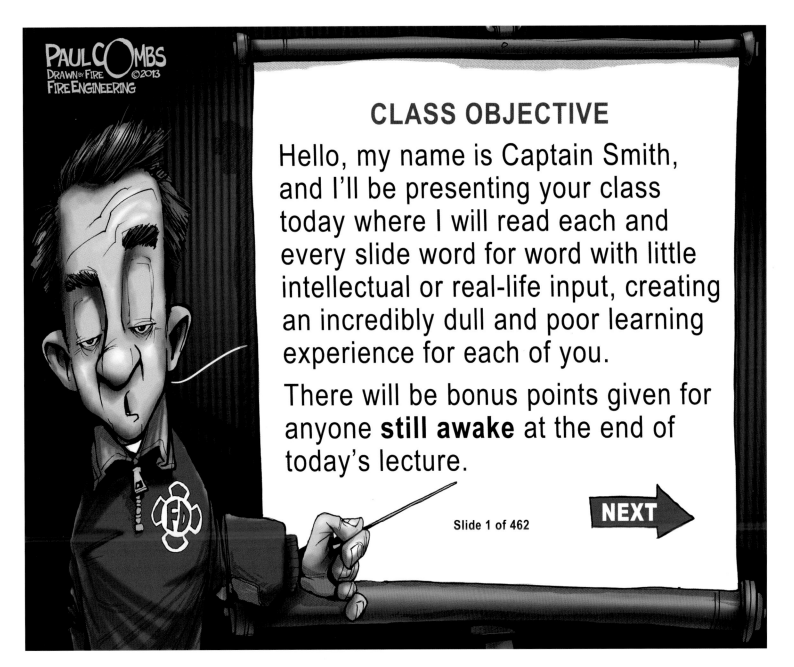

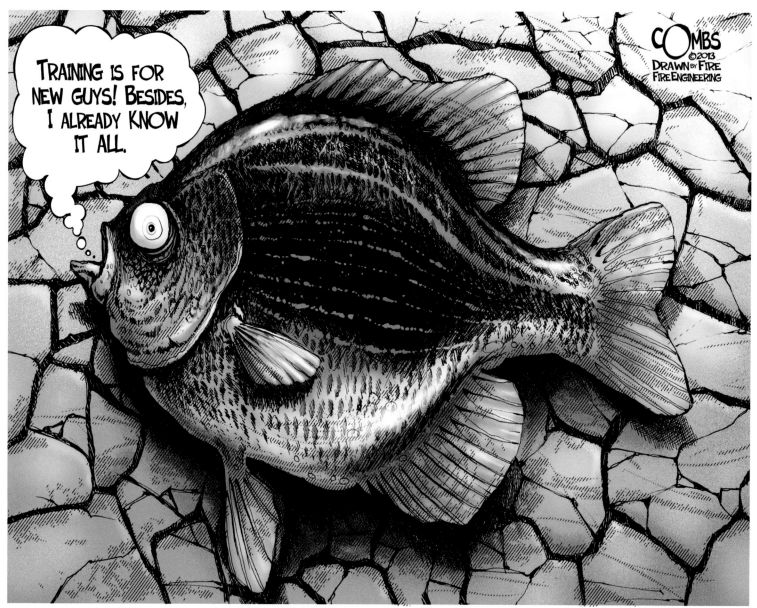

THE FISH OUT OF WATER

Medically Speaking

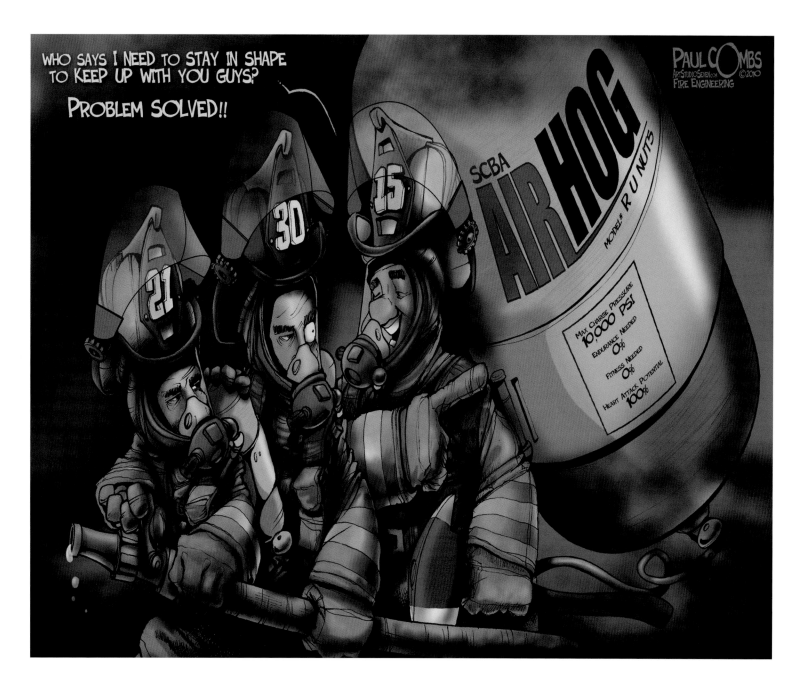

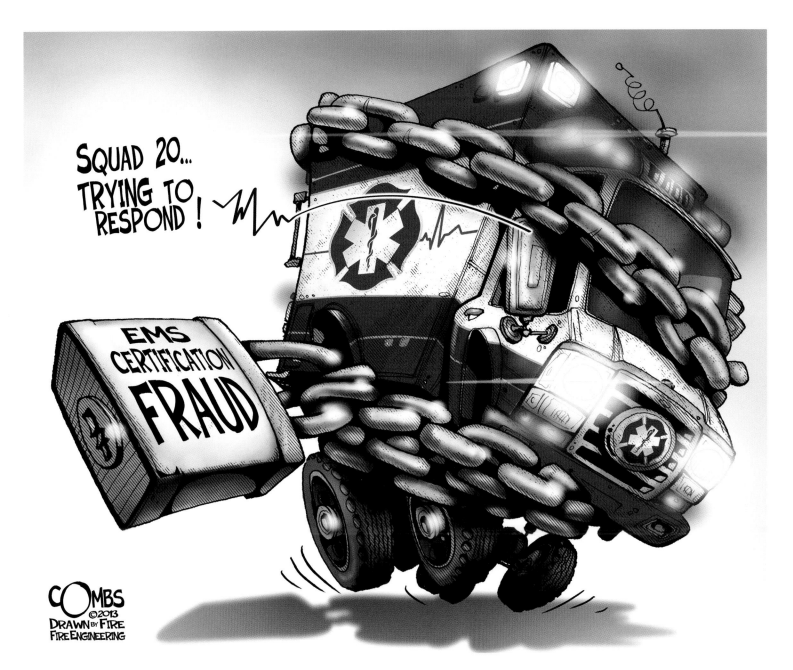

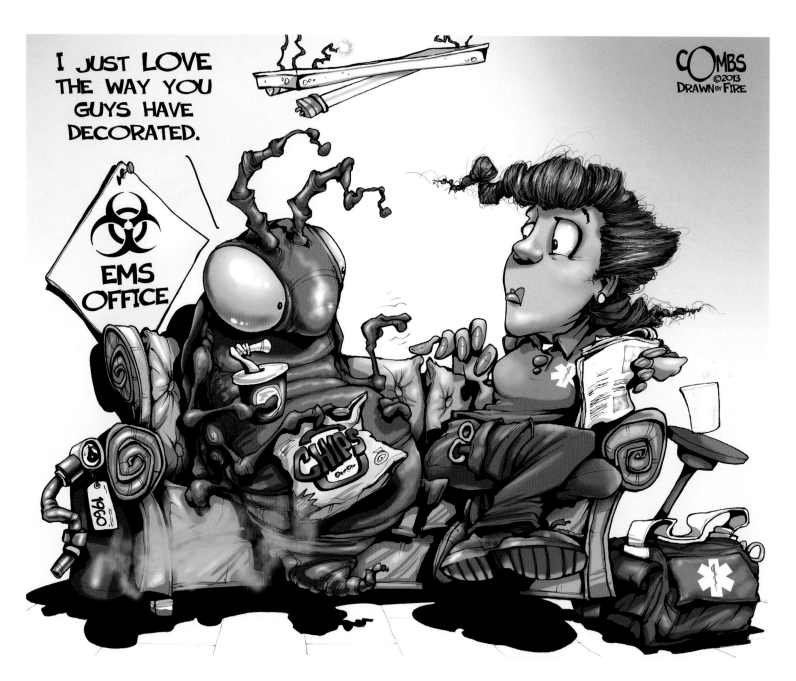

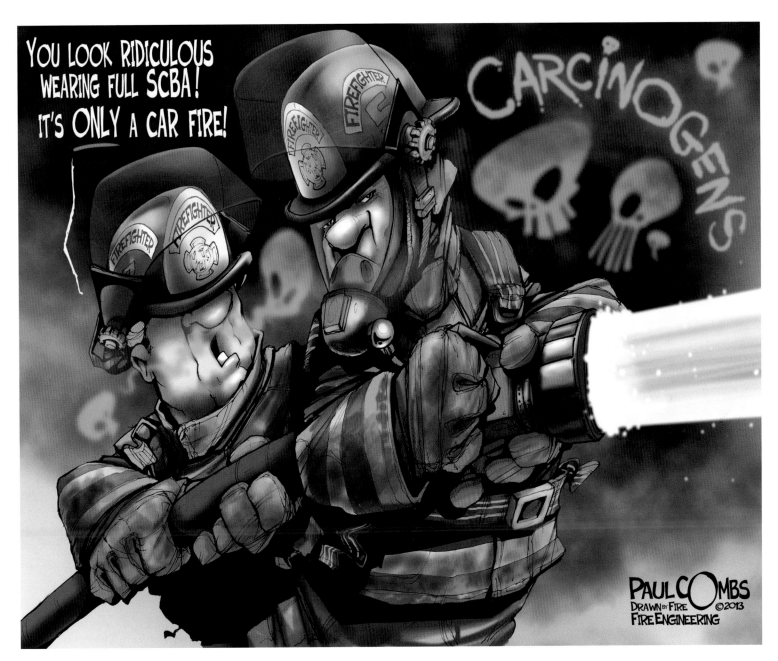

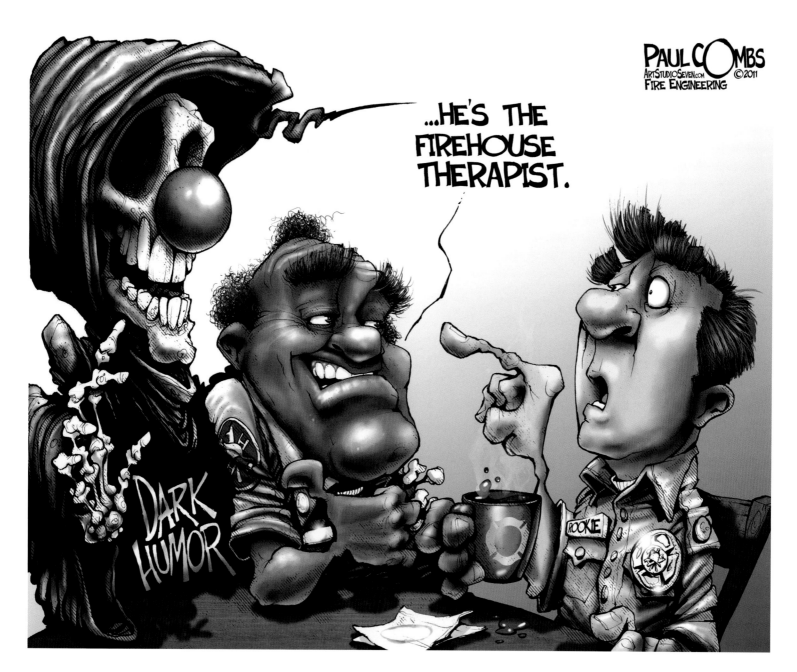

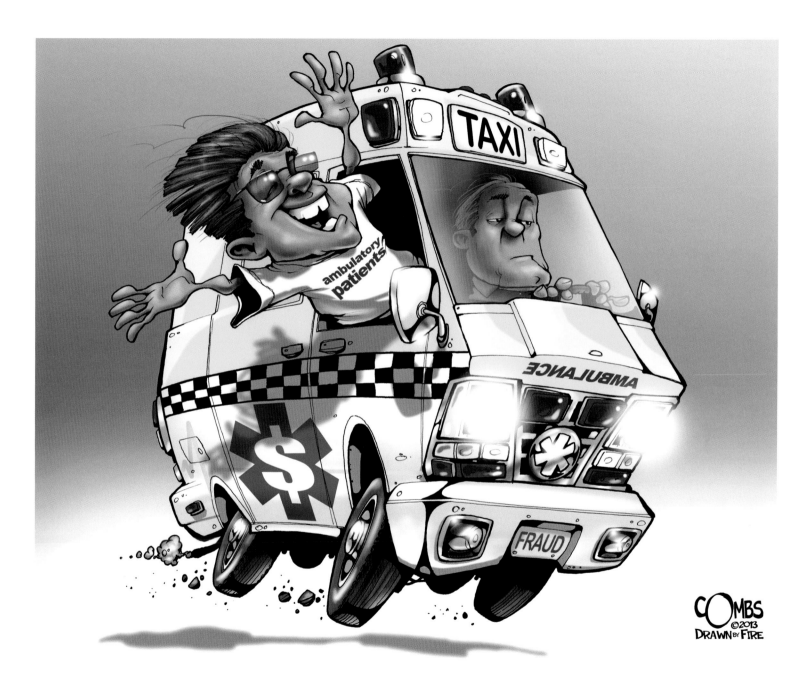

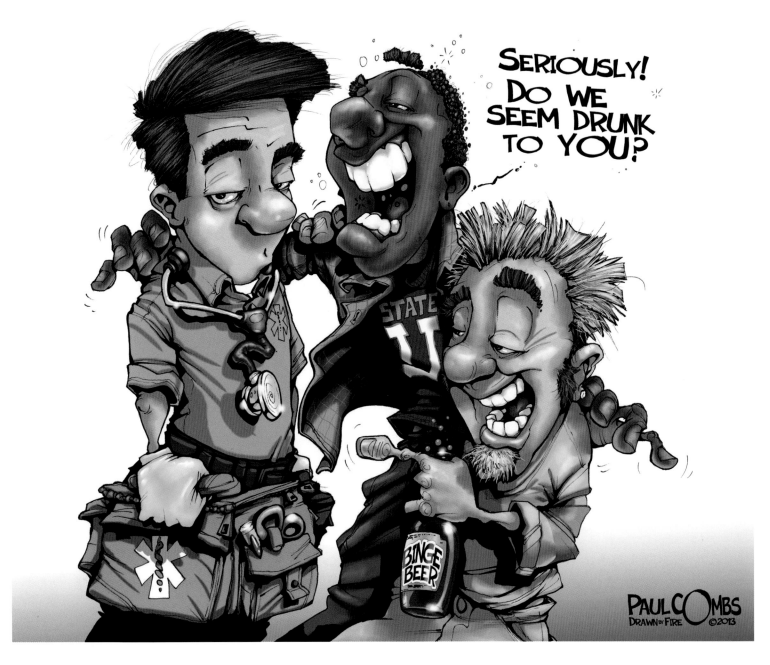

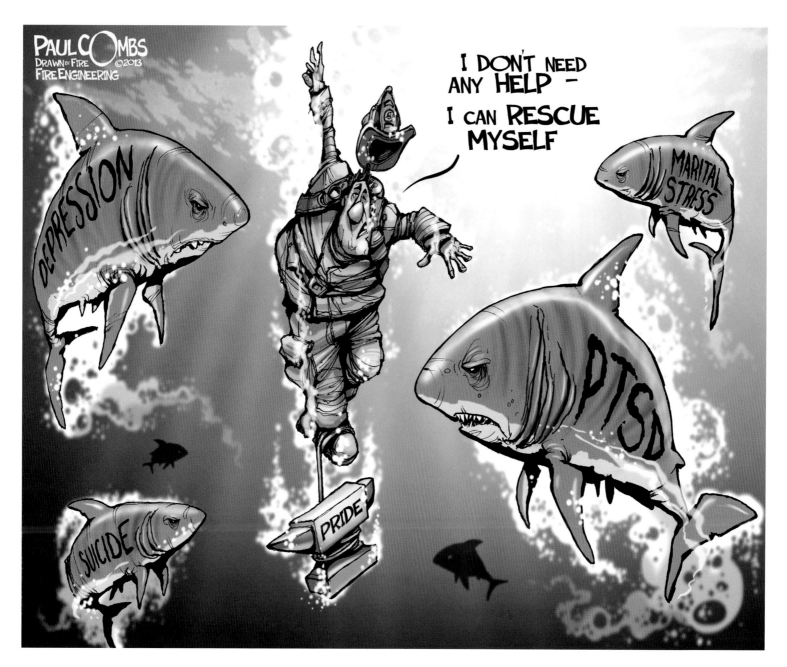

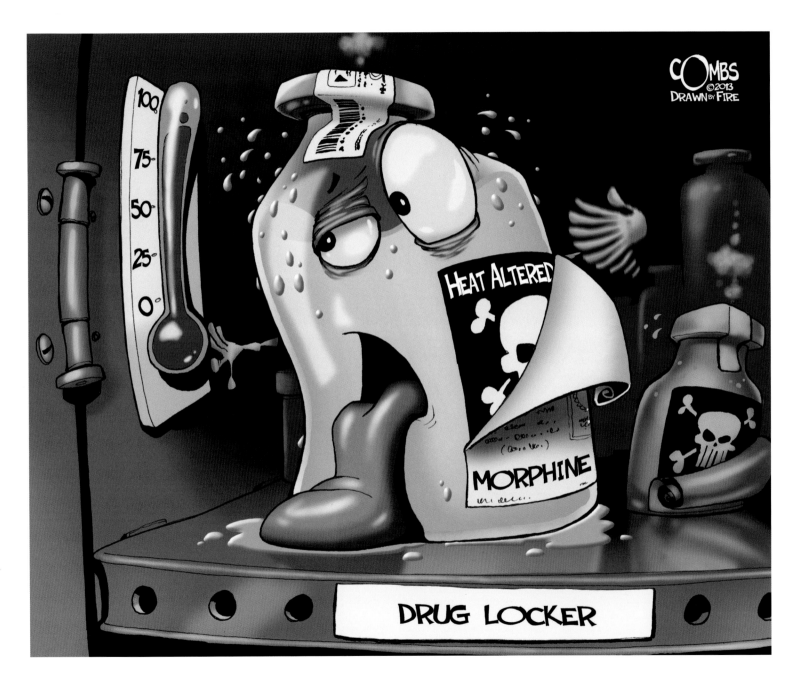

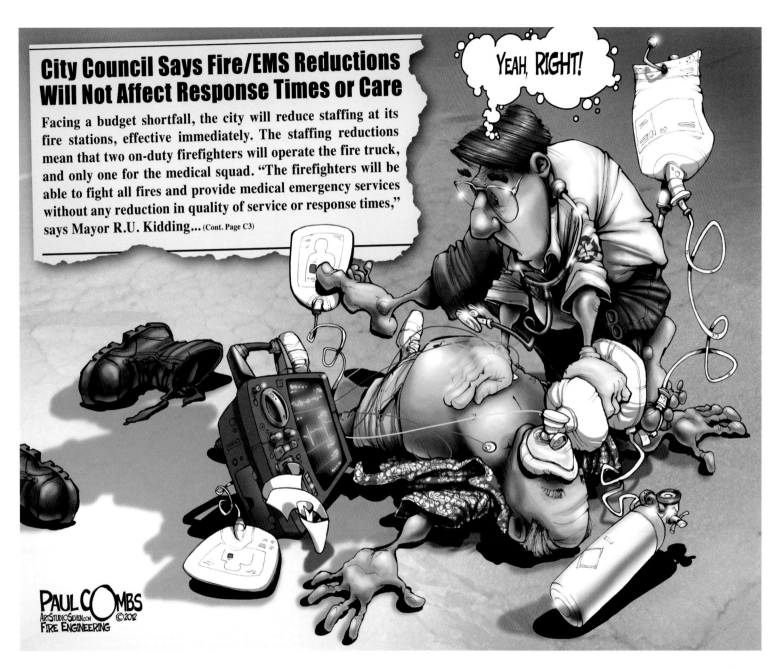

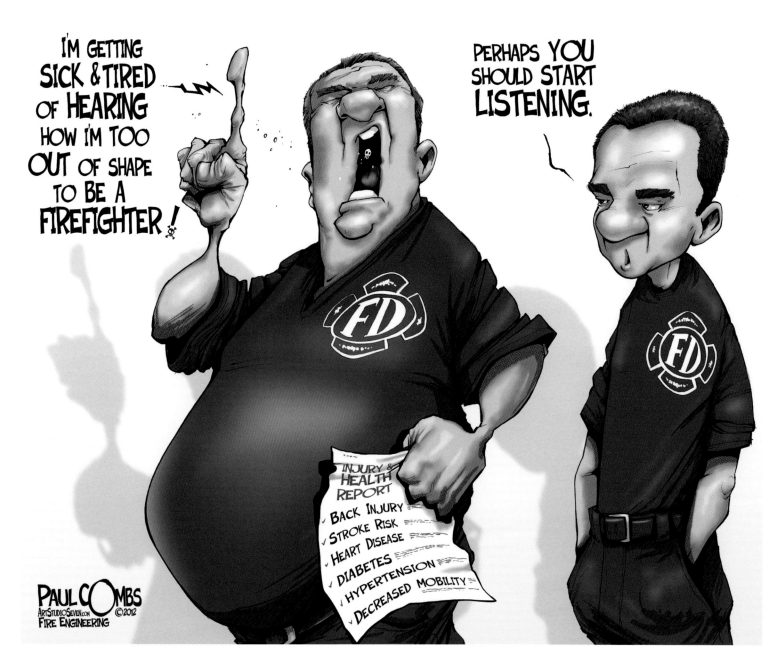

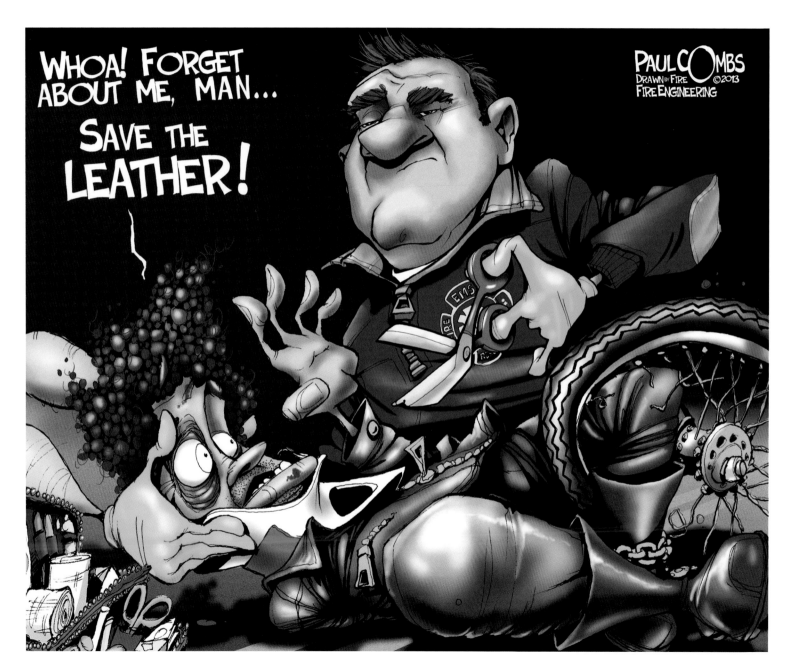

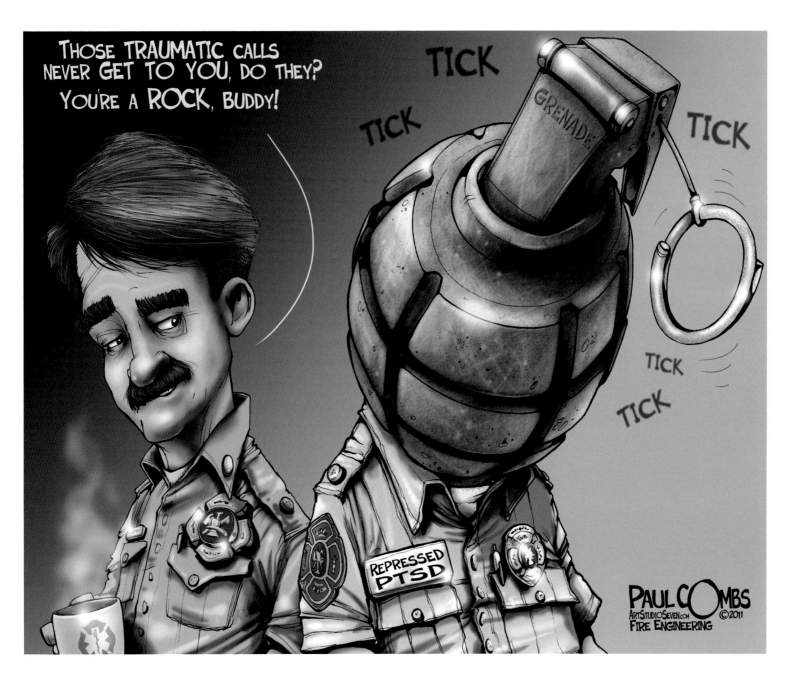

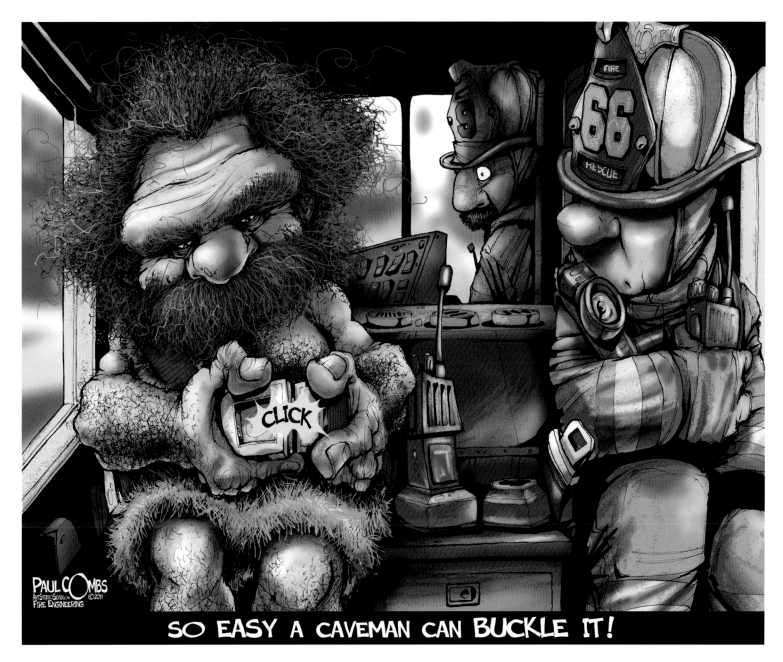

SO EASY A CAVEMAN CAN **BUCKLE** IT!

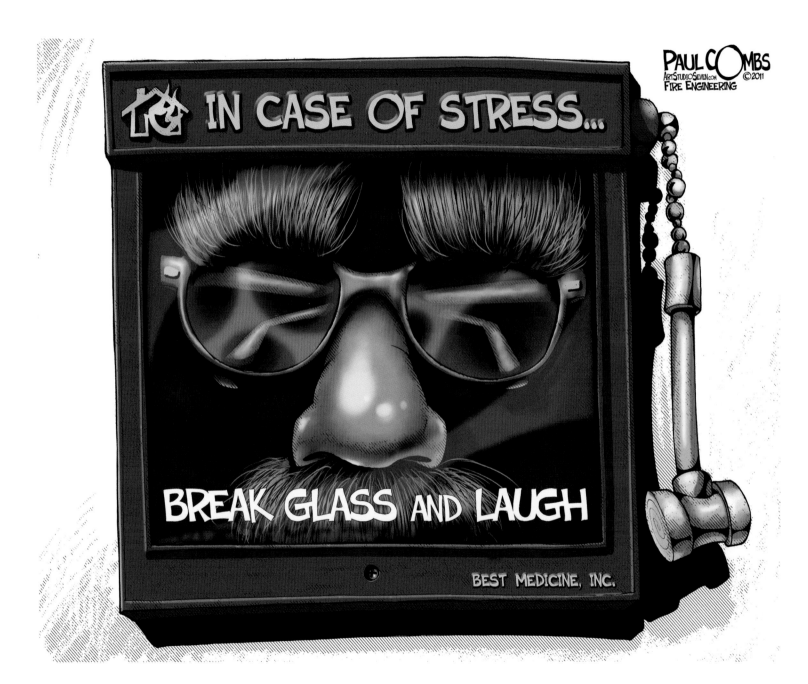

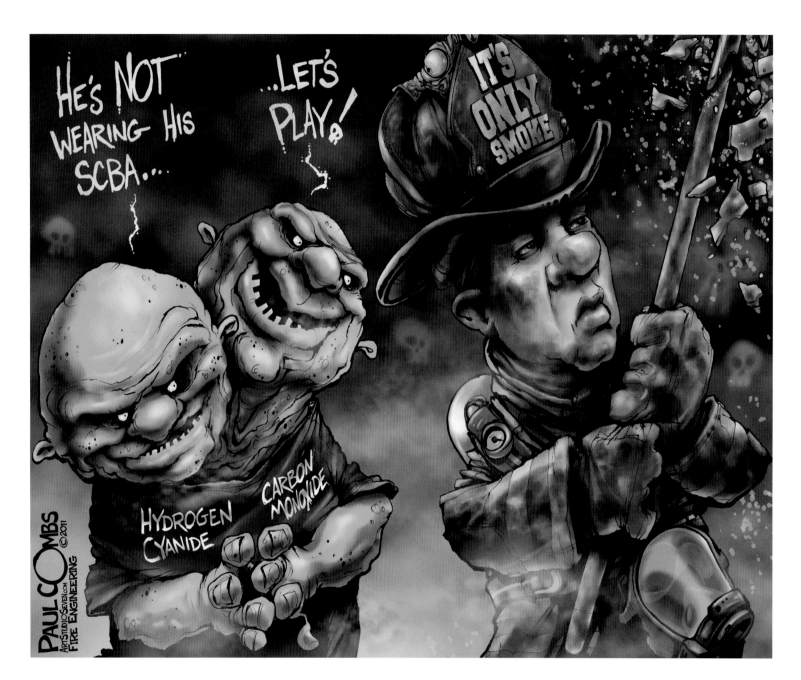

7

Tailboard Talk

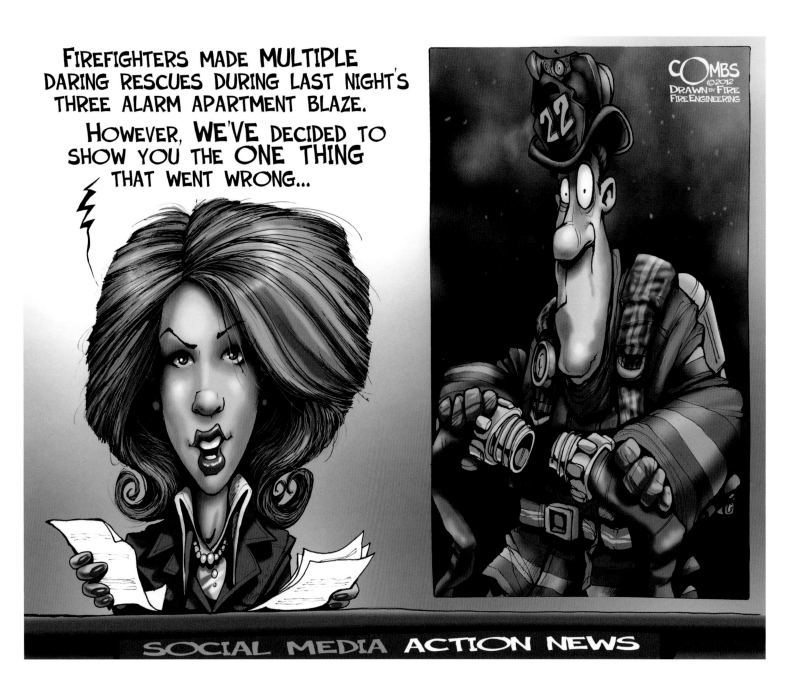

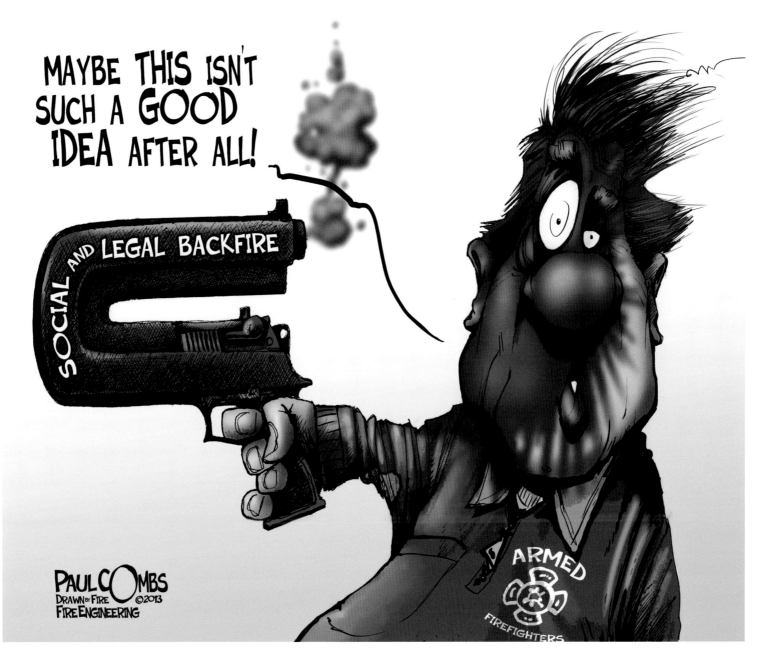

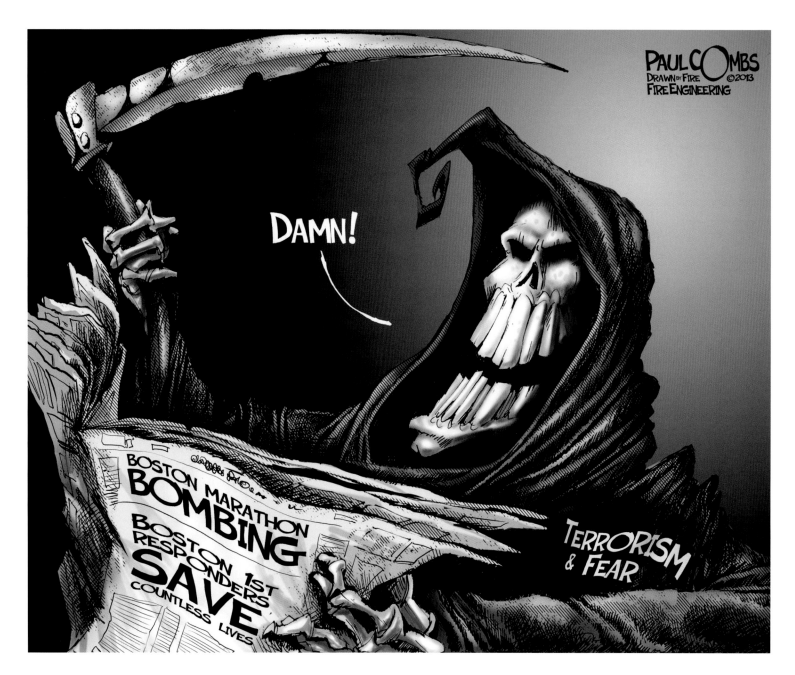

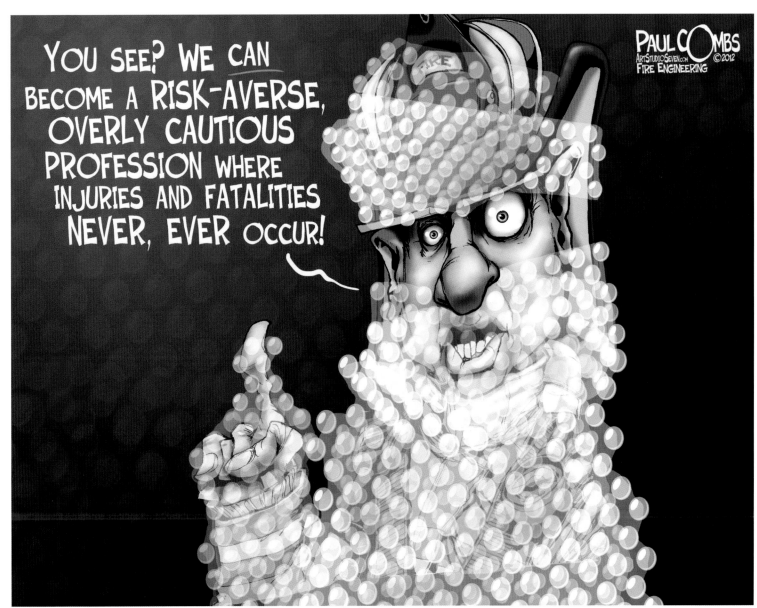

BUBBLE WRAP PHILOSOPHY

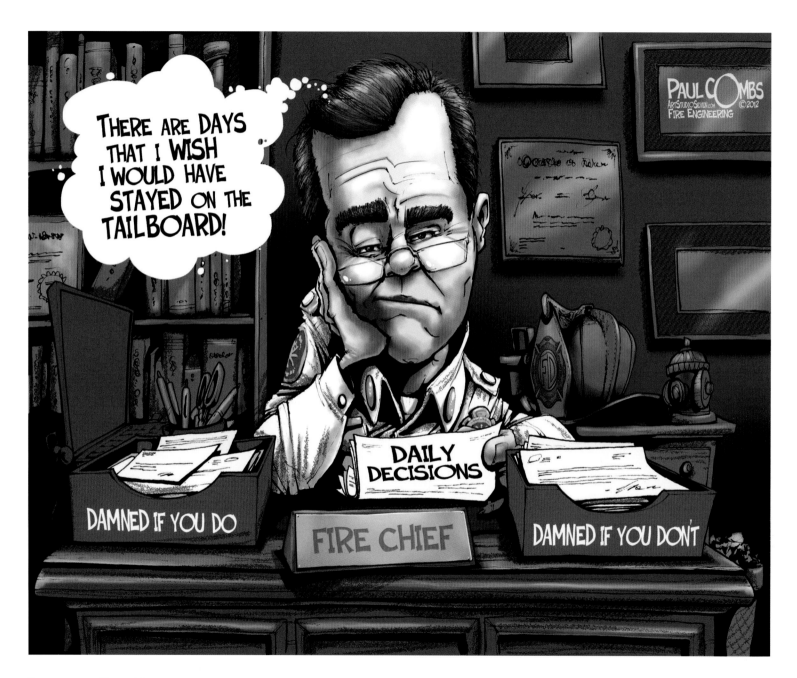

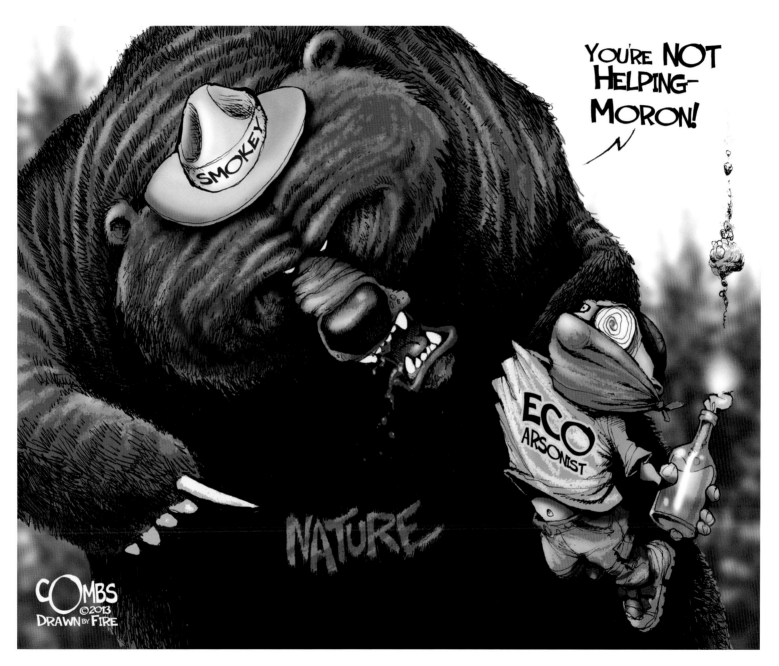

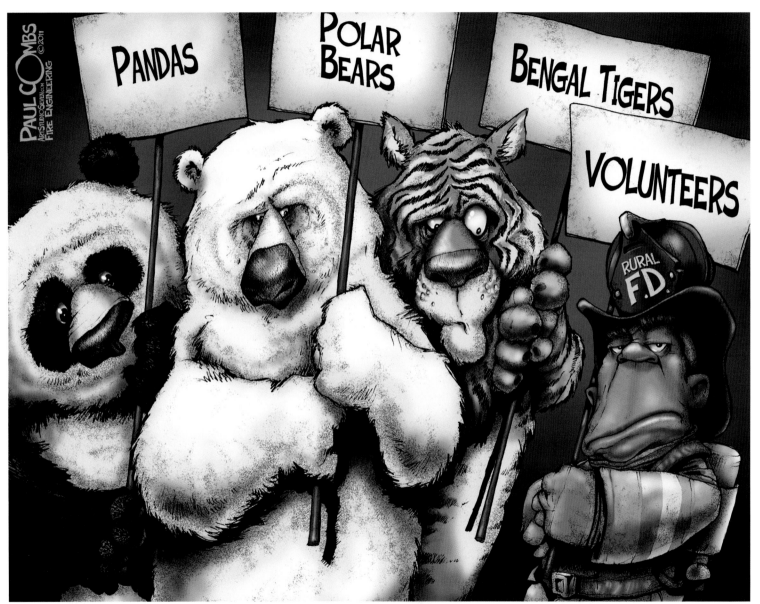

ENDANGERED SPECIES

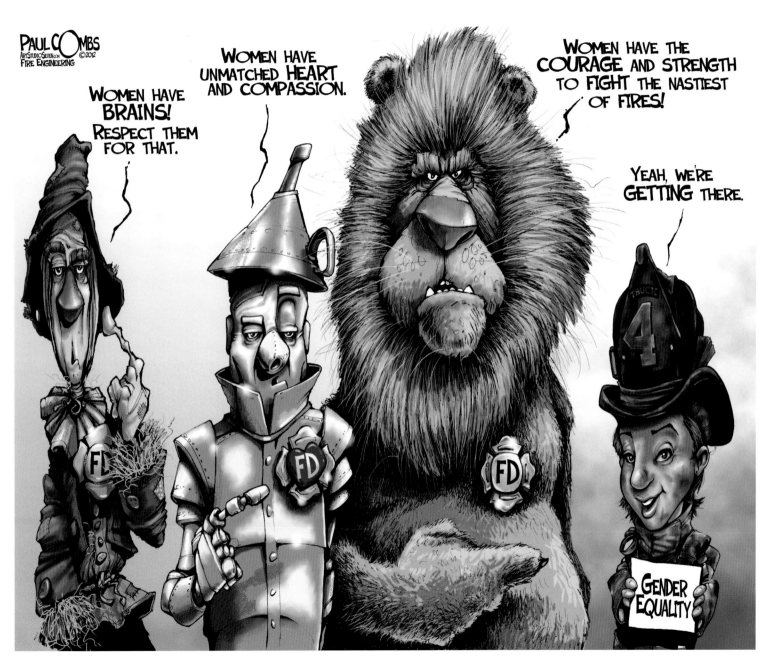

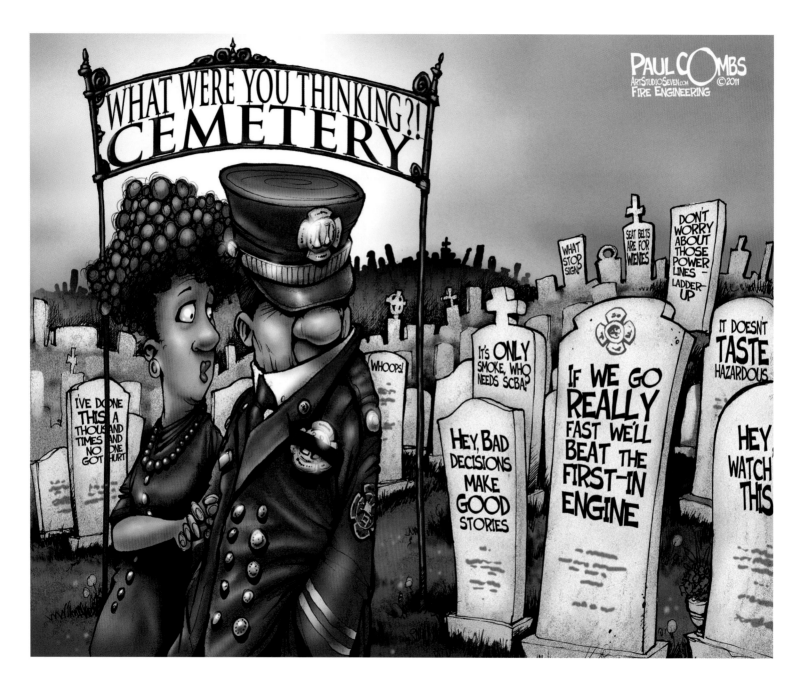

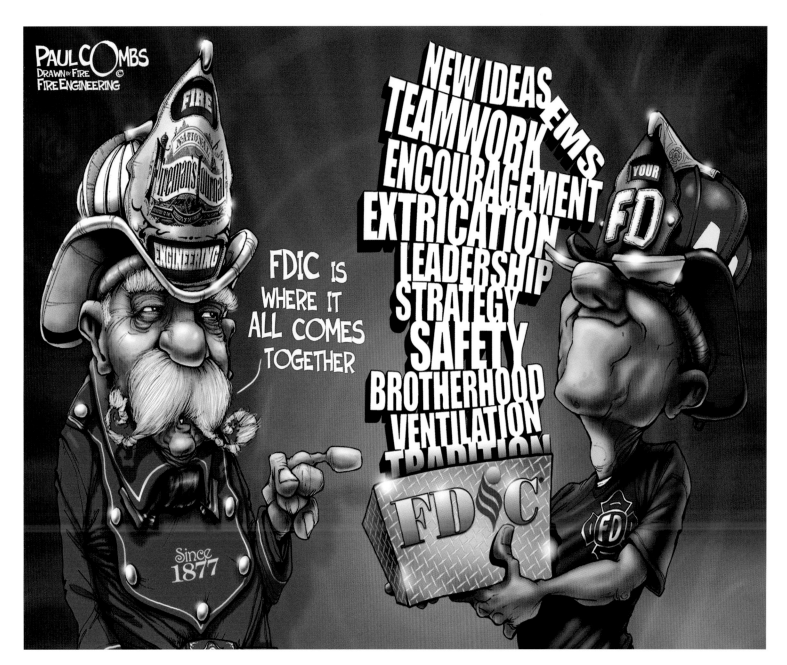

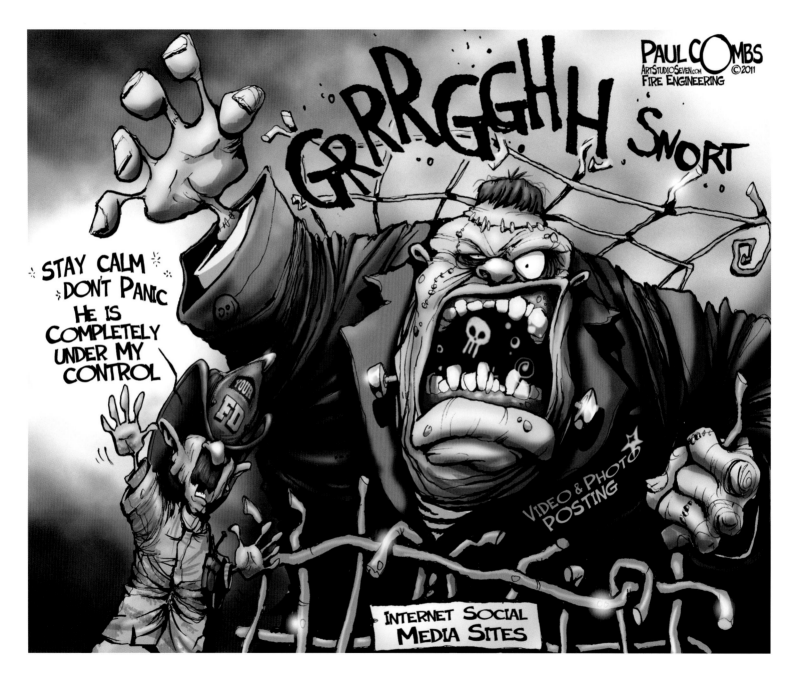

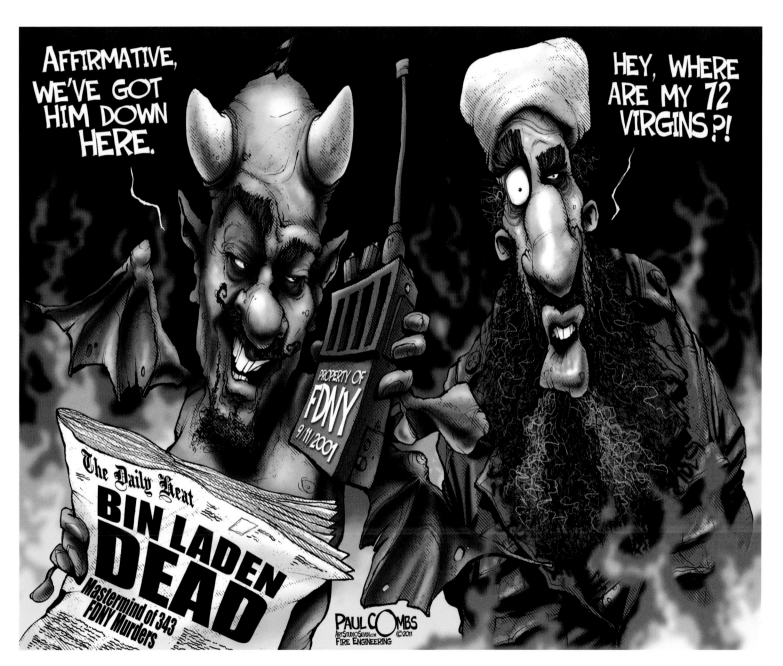

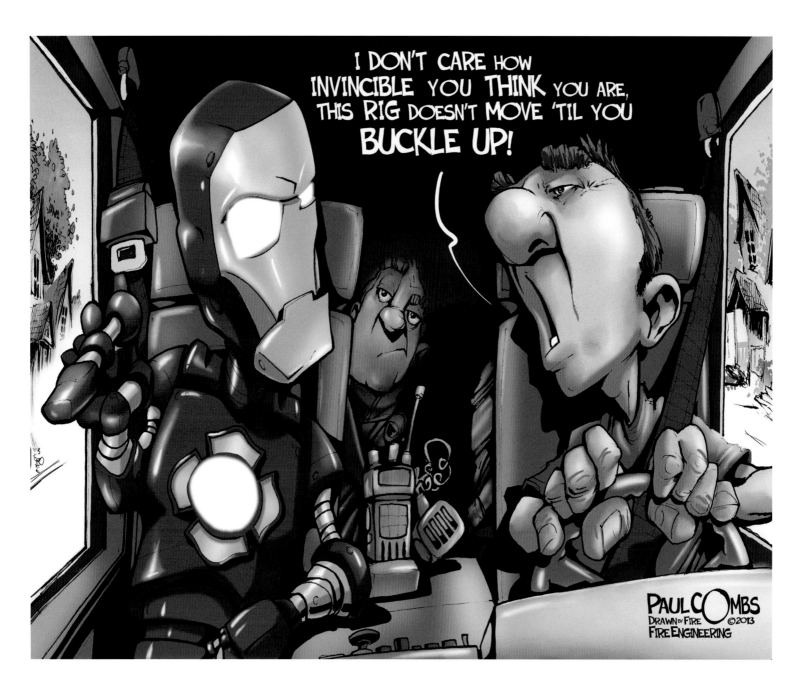

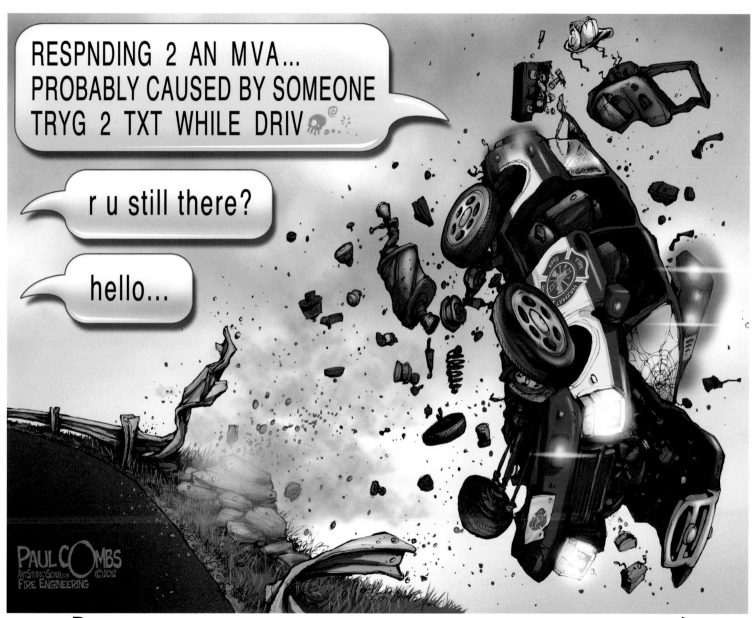

PUT THE GADGET DOWN AND PUT YOUR HANDS BACK ON THE WHEEL!

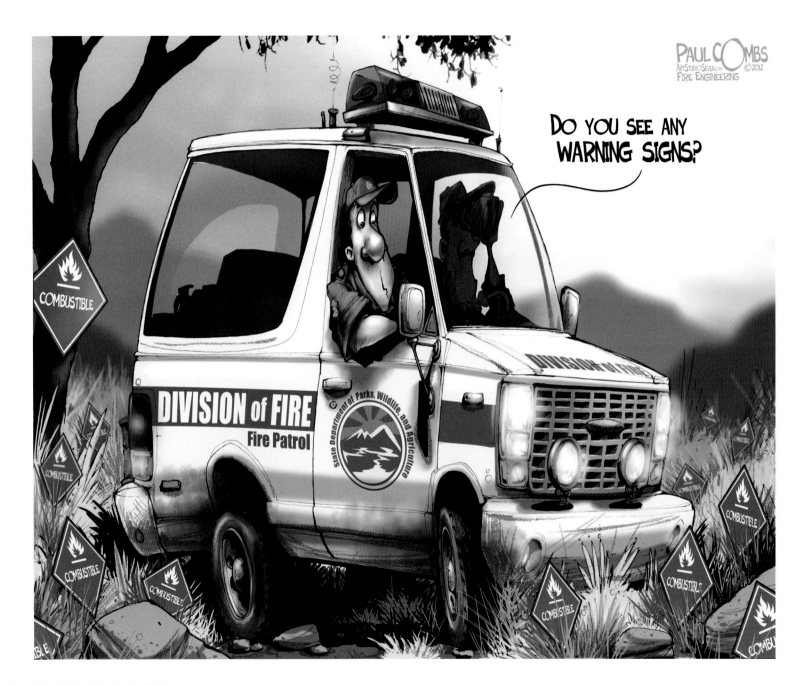

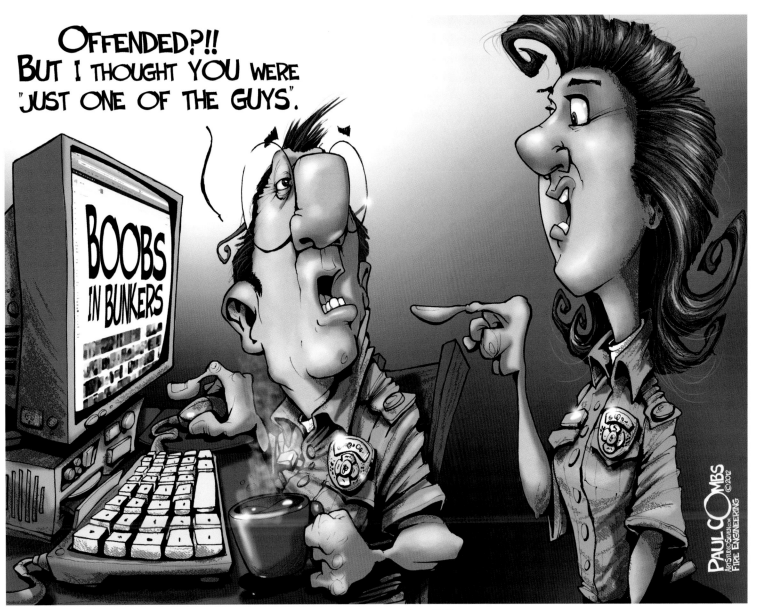

REMEMBER, NOT EVERYONE ENJOYS YOUR SENSE OF ENTERTAINMENT.

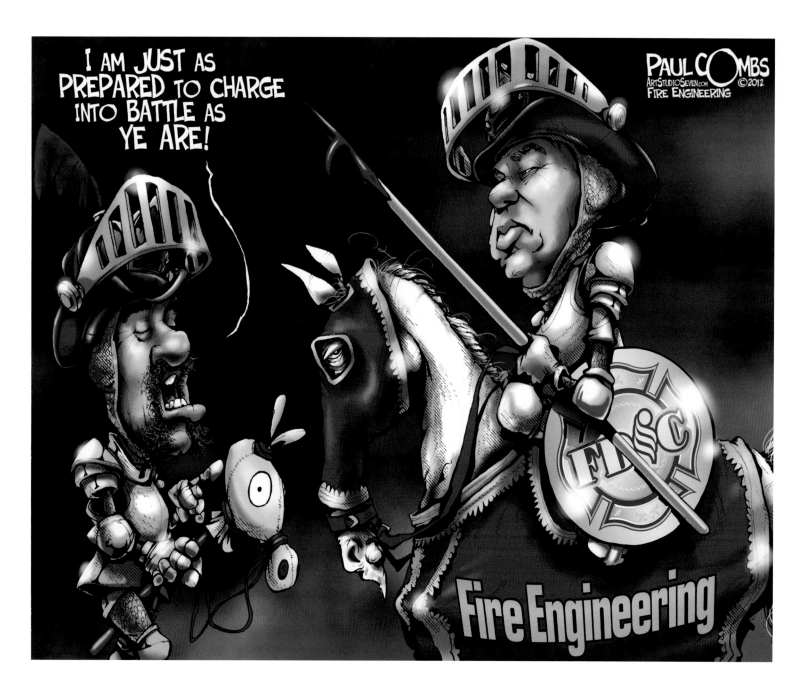

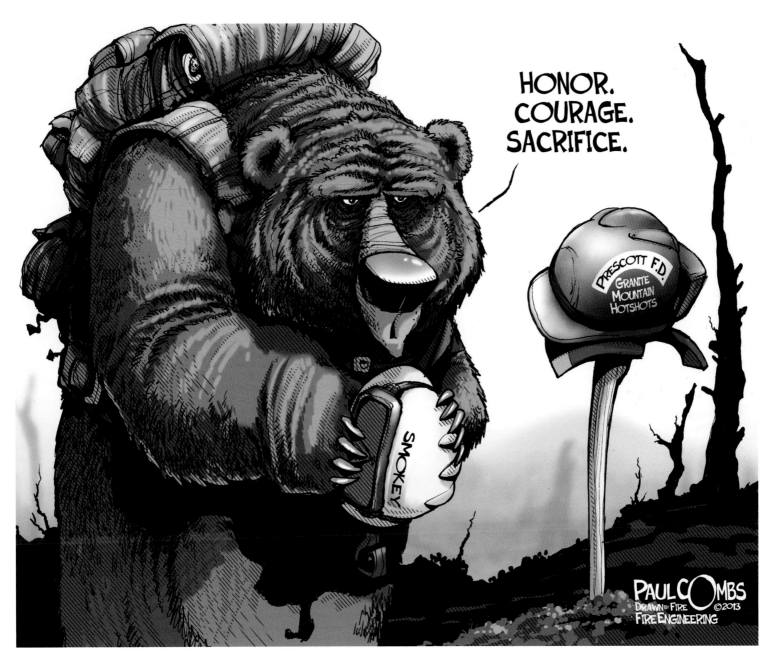

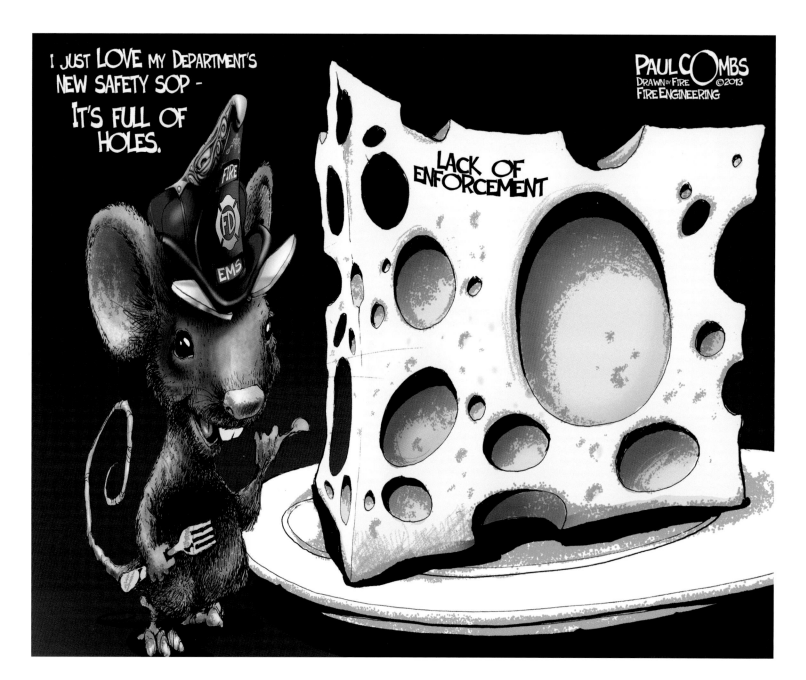

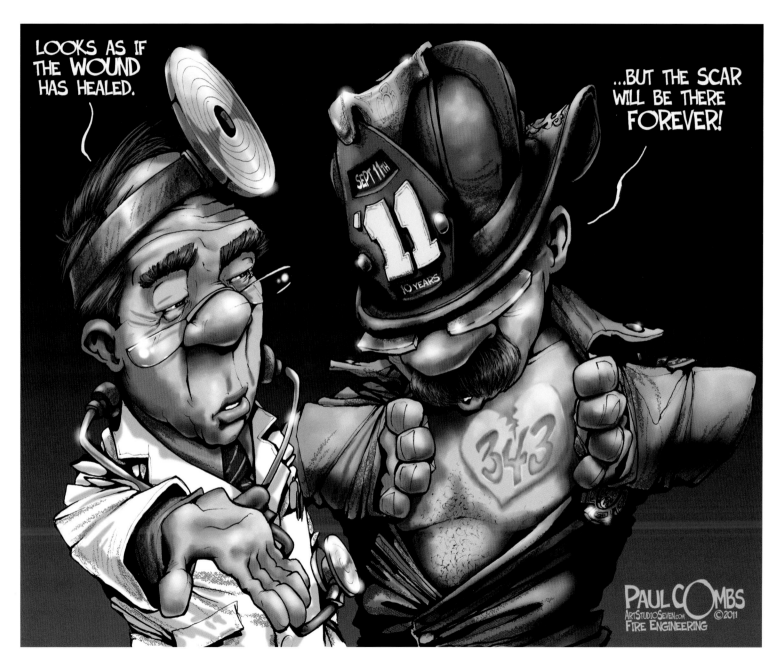

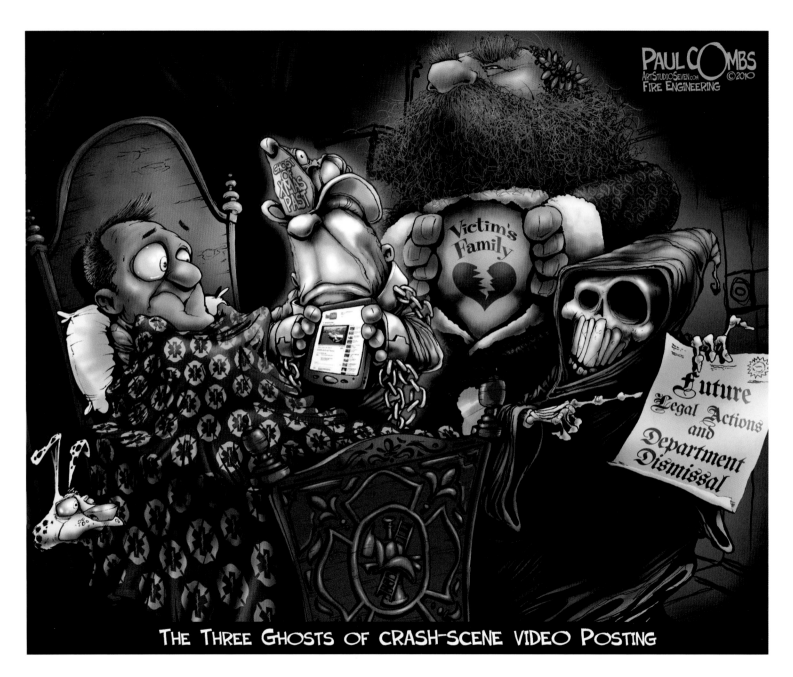

THE THREE GHOSTS OF CRASH-SCENE VIDEO POSTING

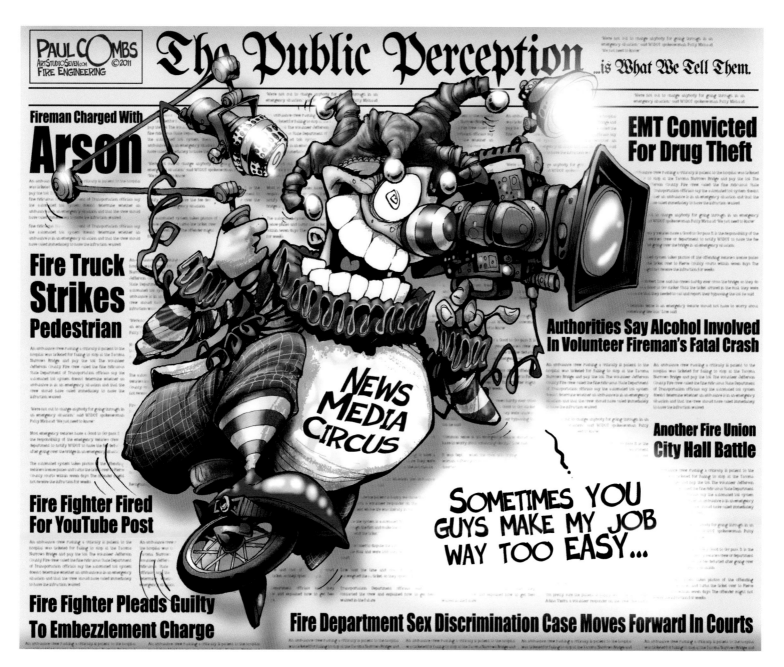

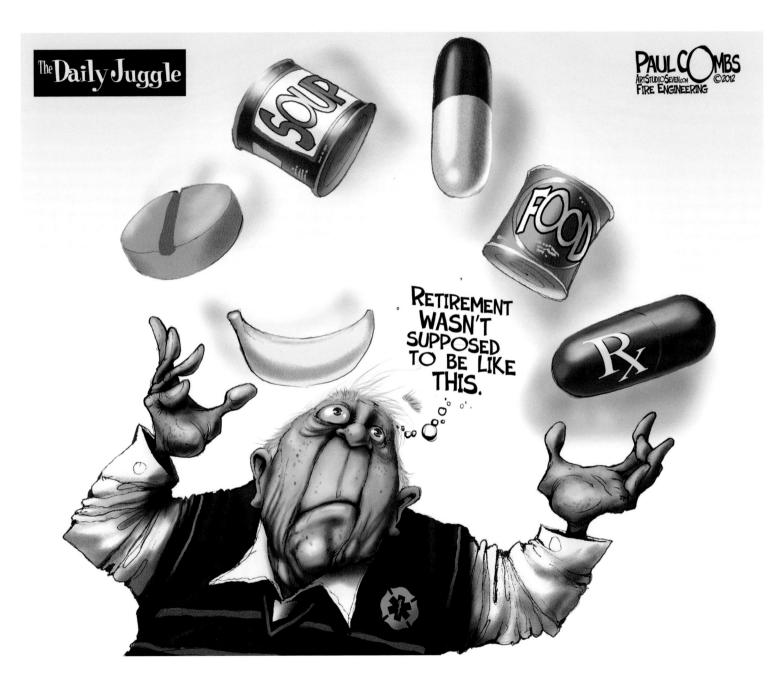

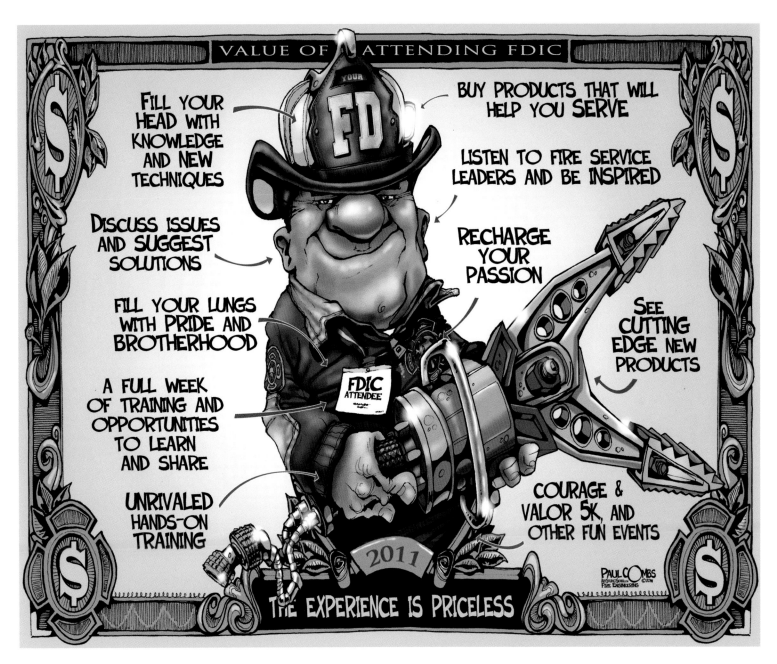

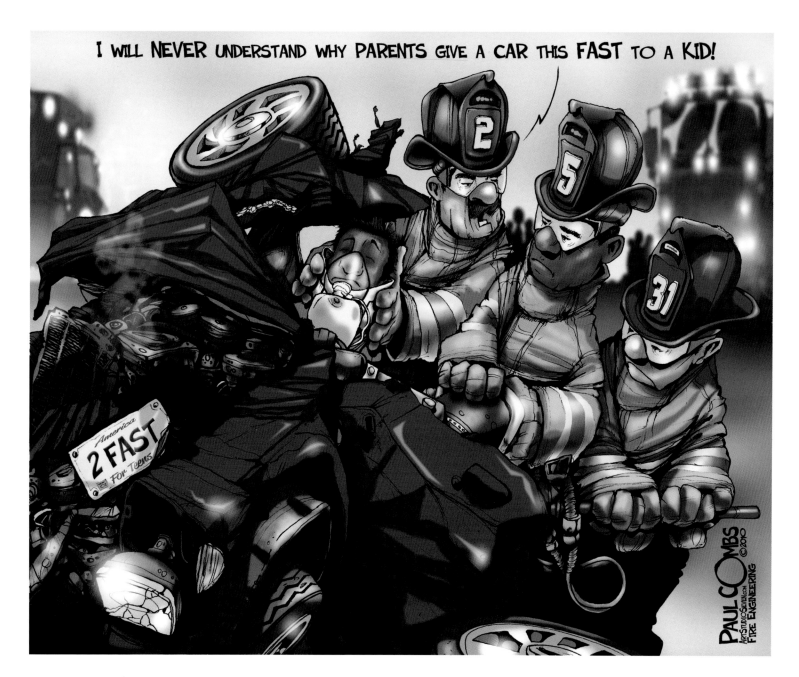

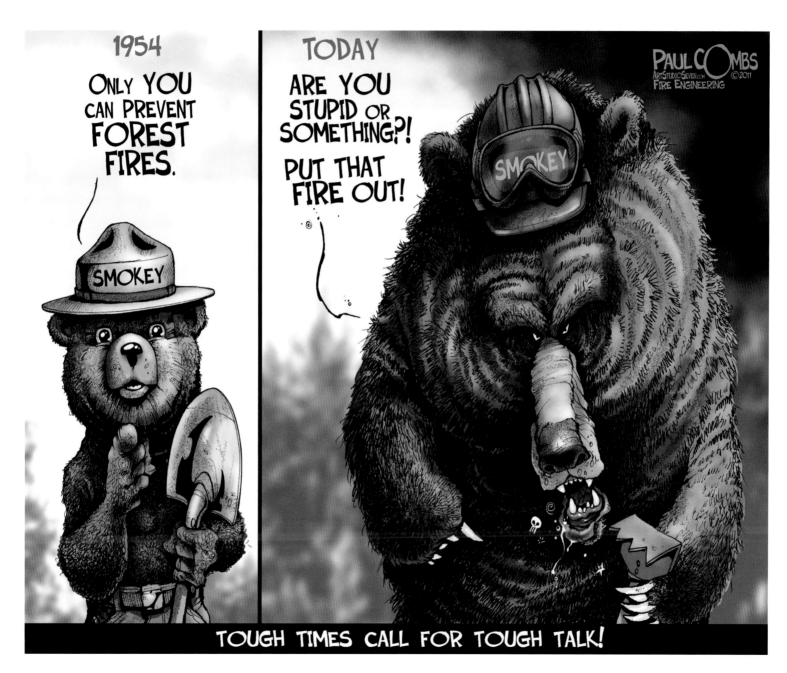

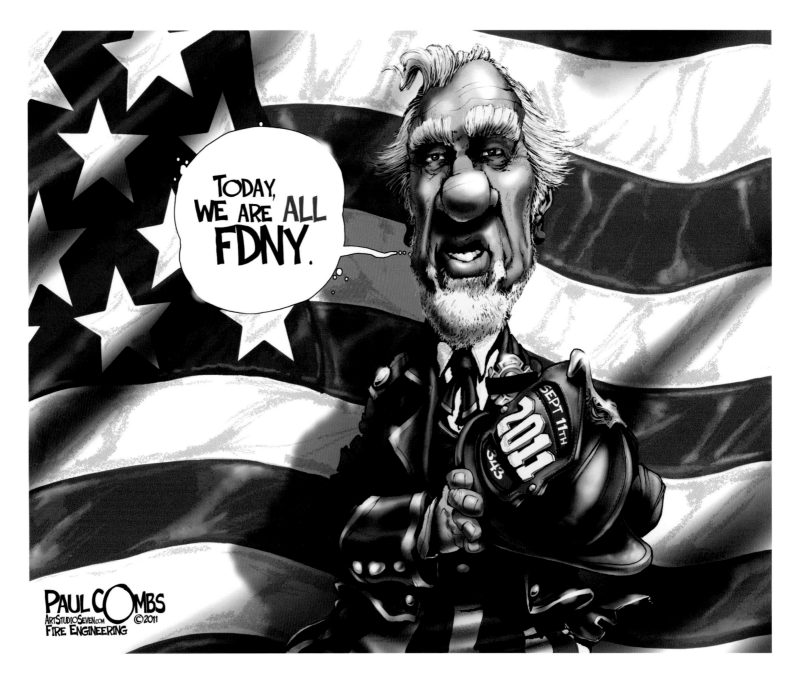

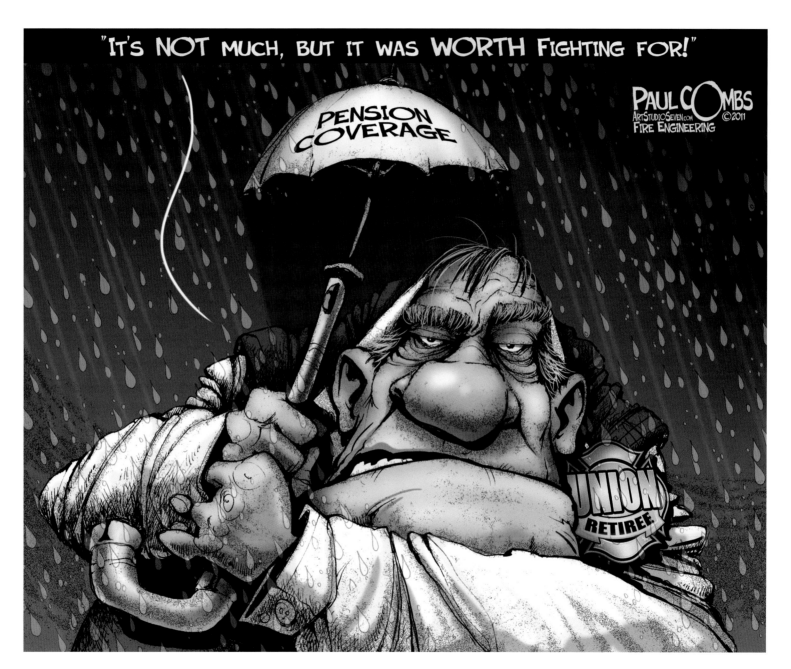

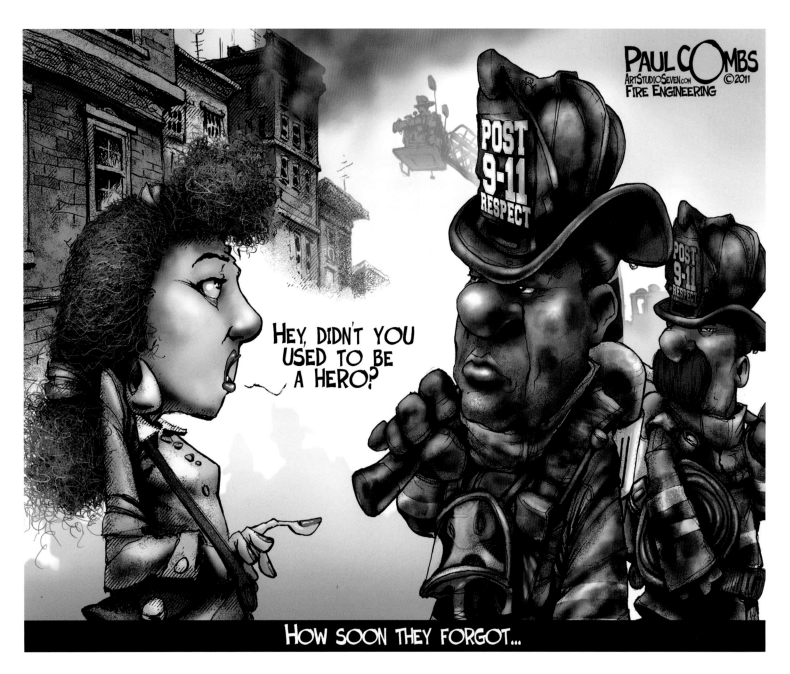

I'm Having Flashbacks

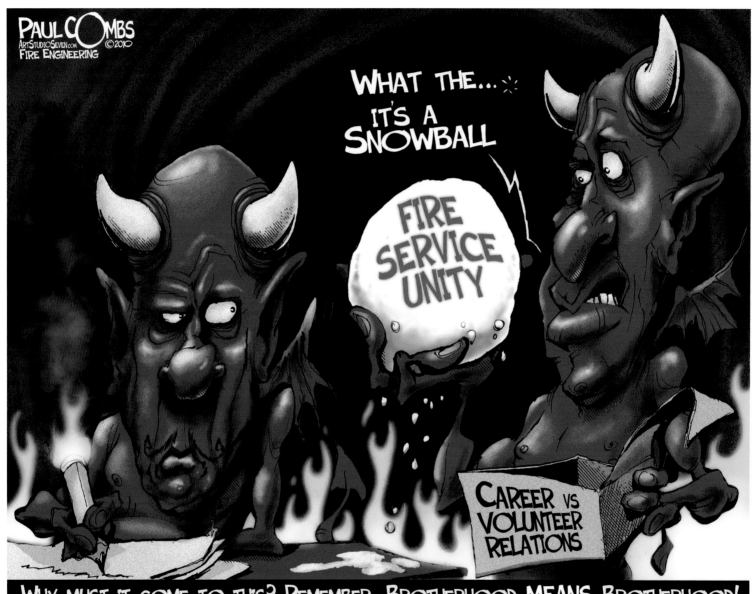

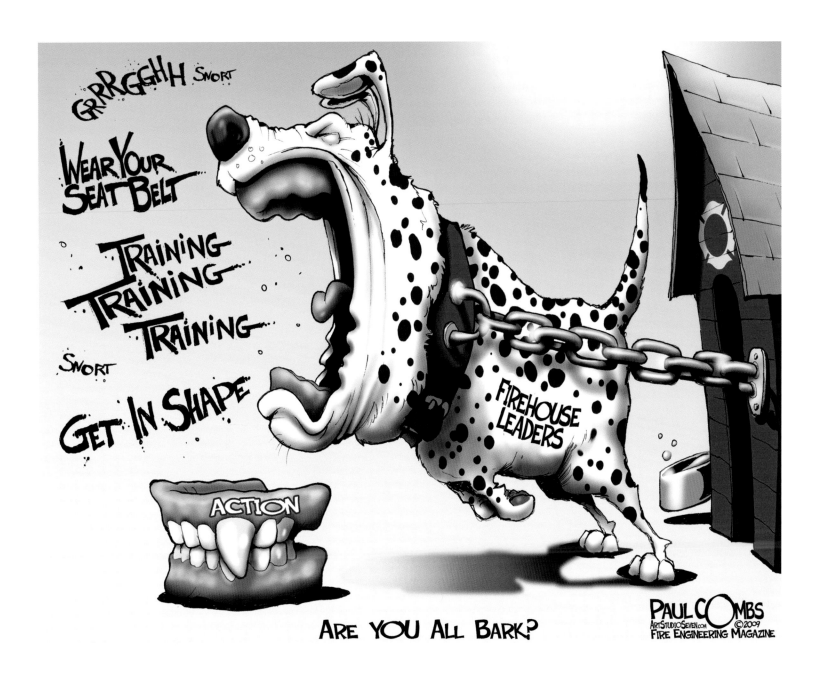

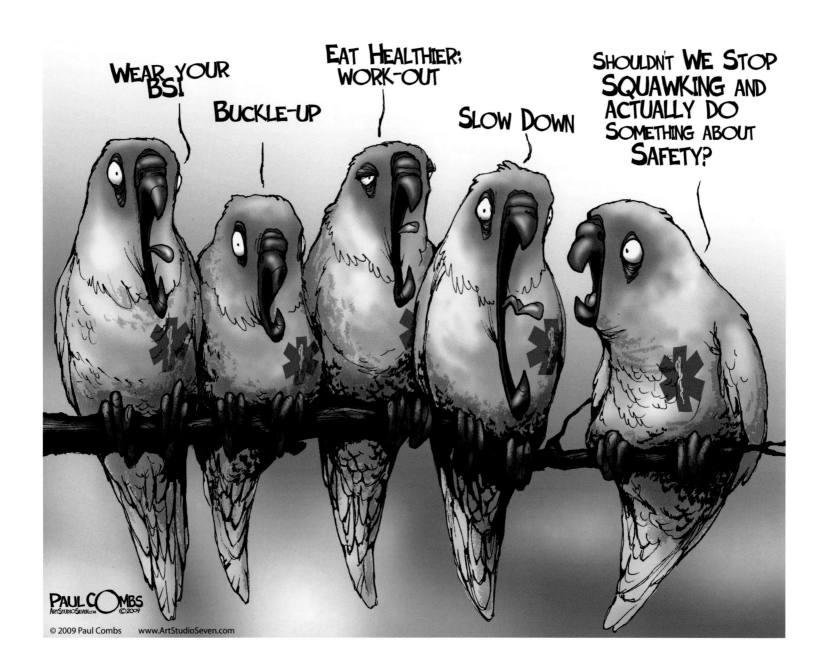

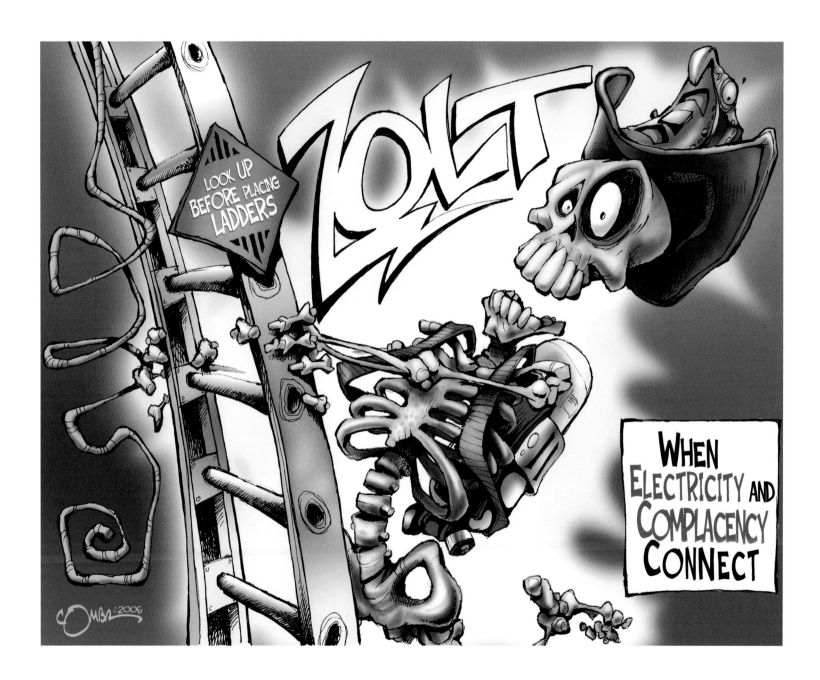

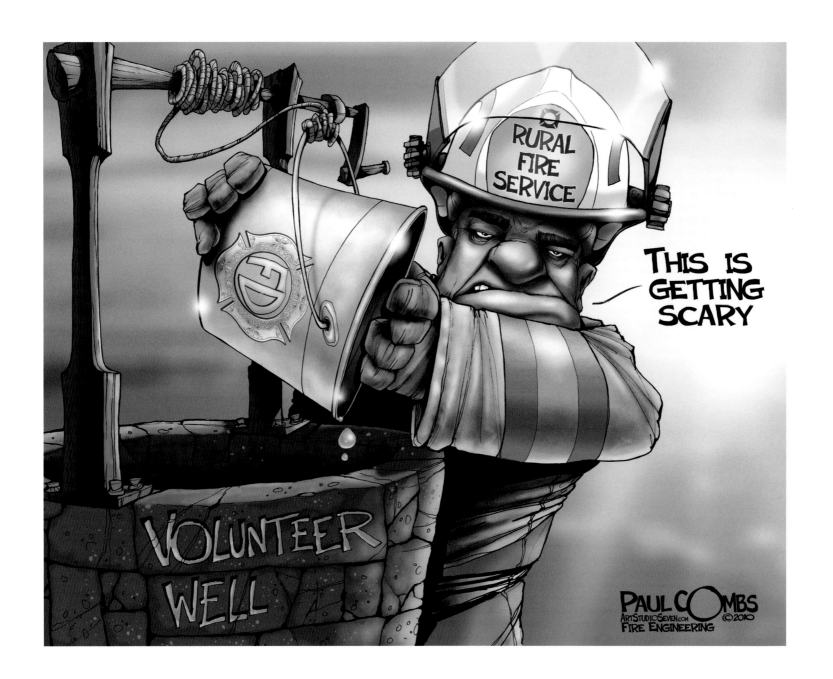

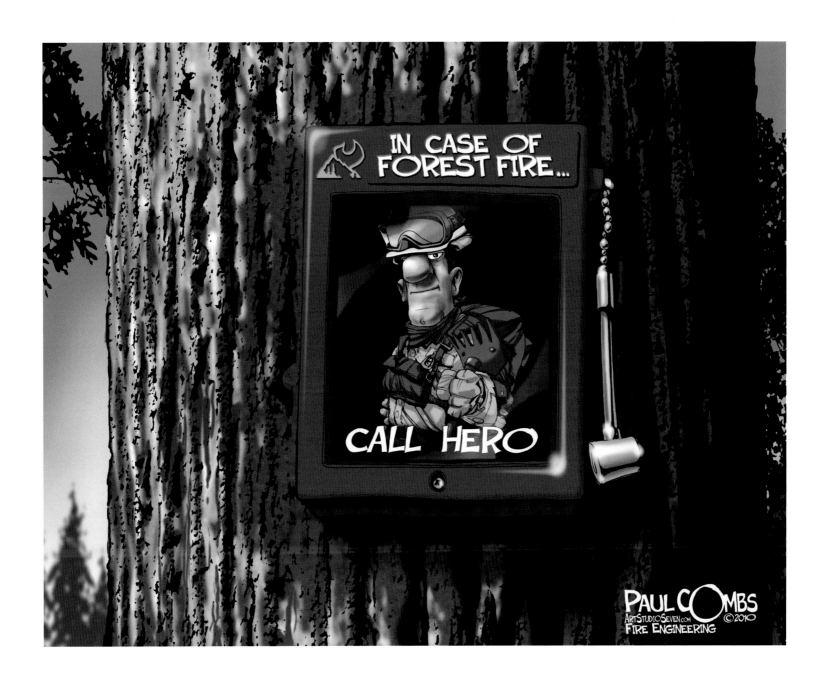

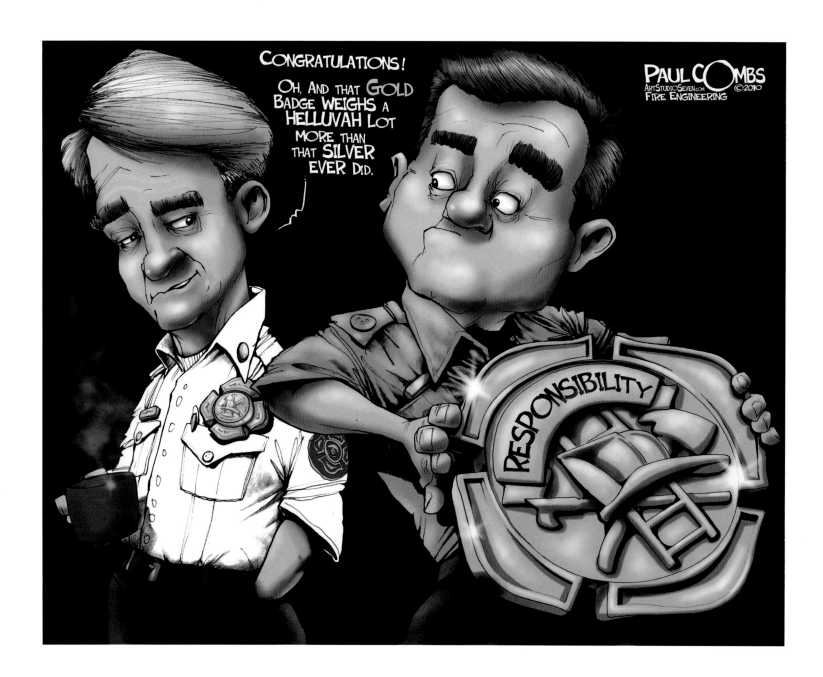

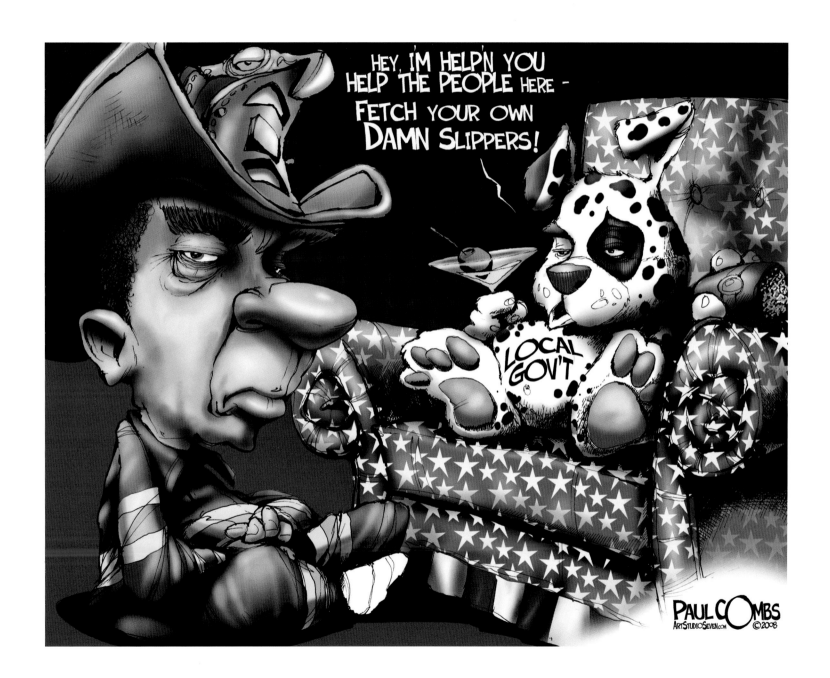

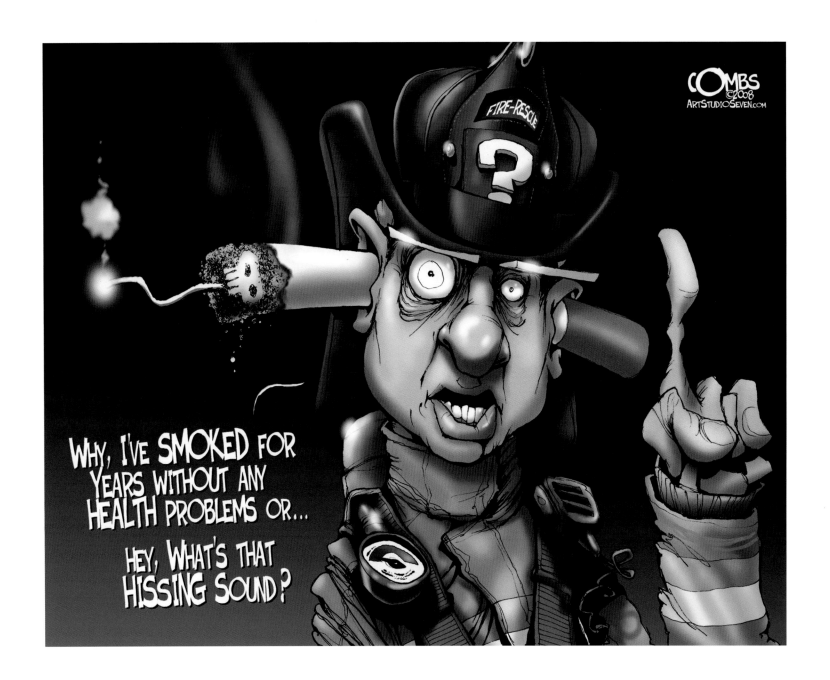

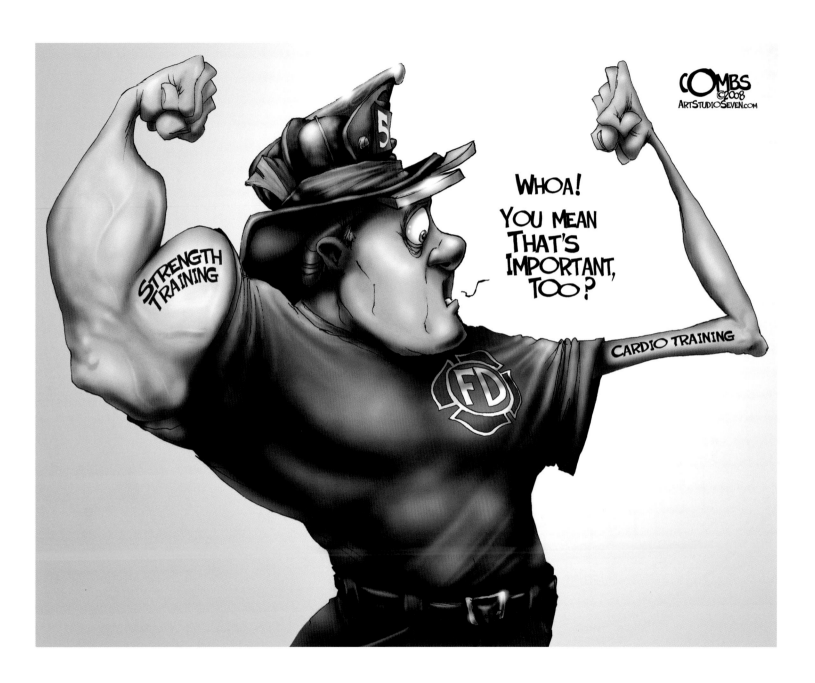

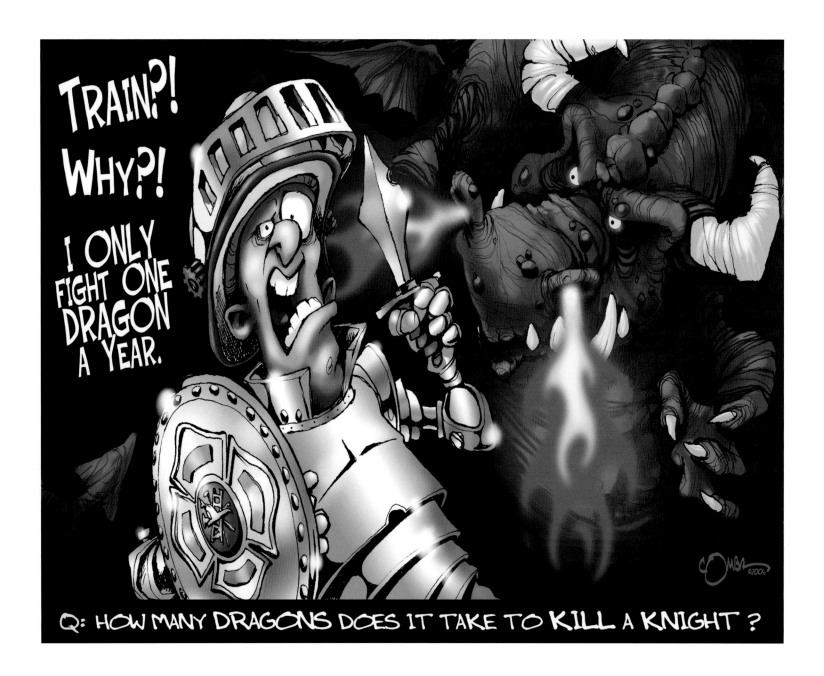

PAUL COMBS
ArtStudioSeven.com ©2009
FIRE ENGINEERING MAGAZINE

BUCKLE UP
WHILE YOU'RE
RESPONDING
IN THIS...

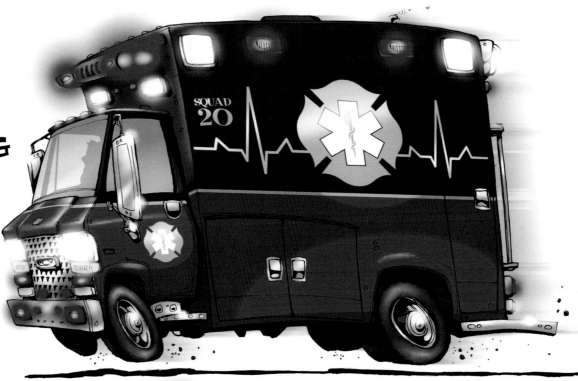

OR YOU
MAY GET A
LONG SLOW
RIDE
IN THIS.

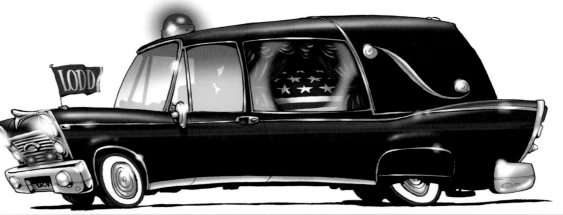

ANY QUESTIONS?

I'm Having Flashbacks 143

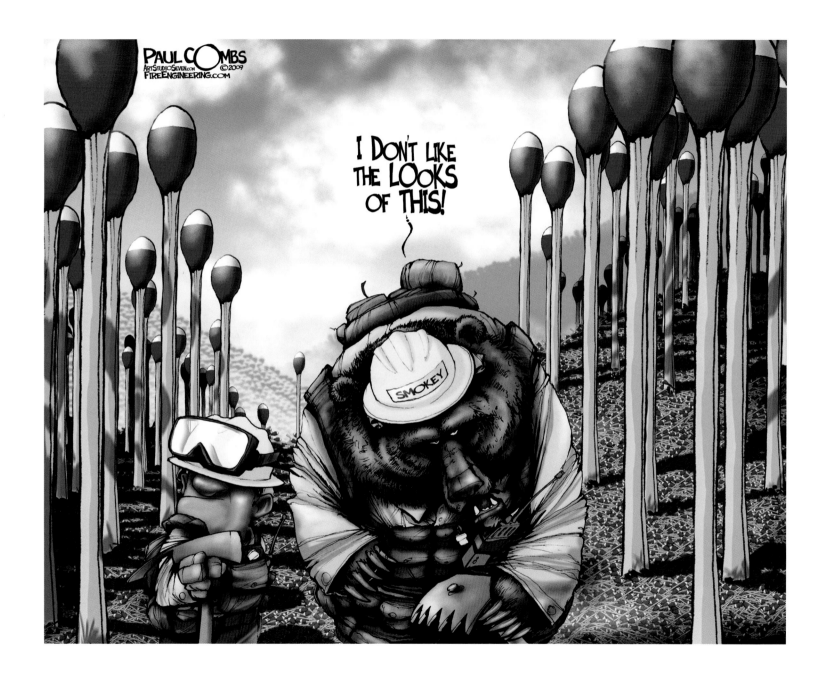

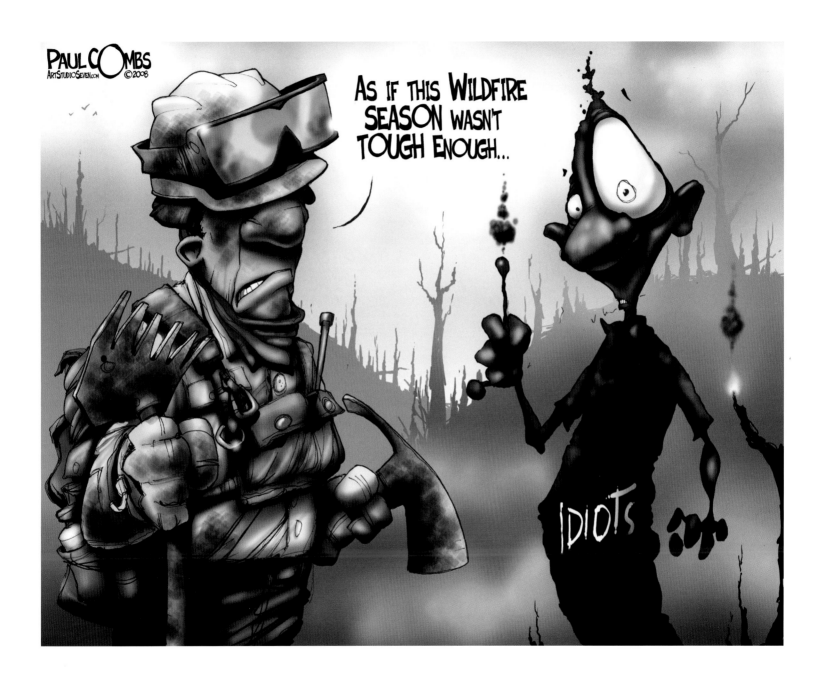

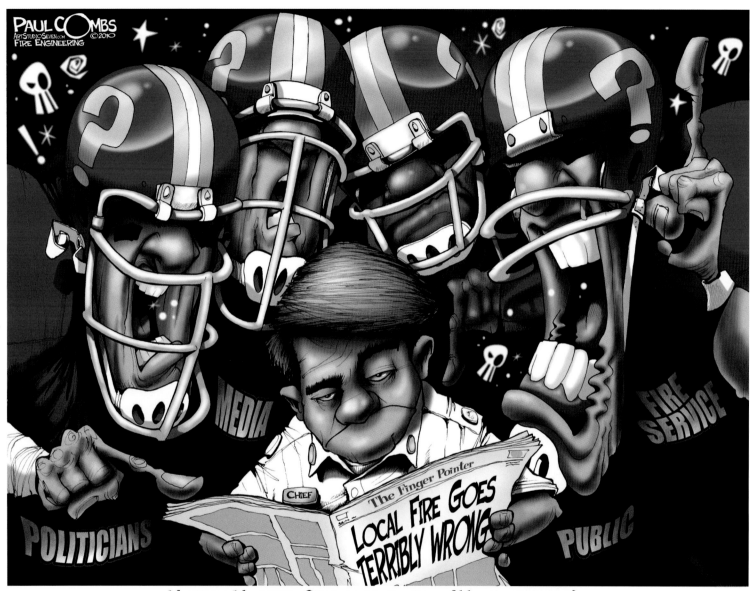

MONDAY MORNING QUARTERBACKS HAVE ALL THE ANSWERS!

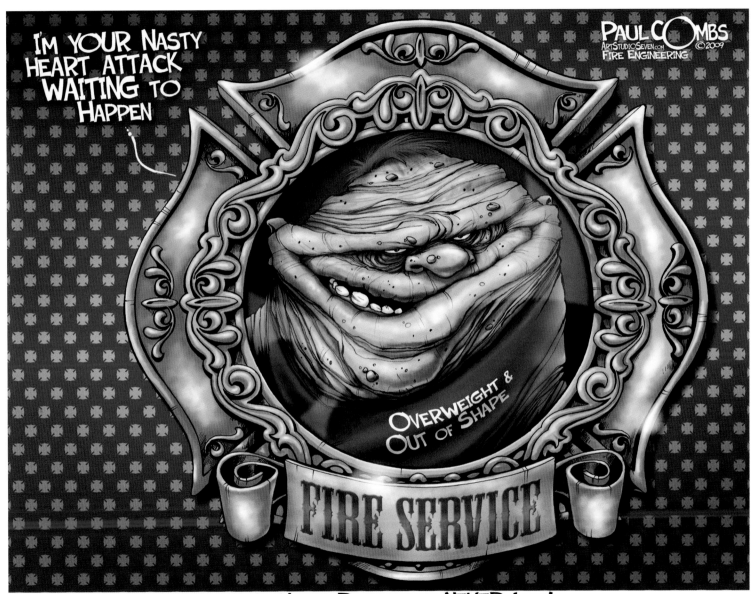

...AND YOUR REFLECTION NEVER LIES!

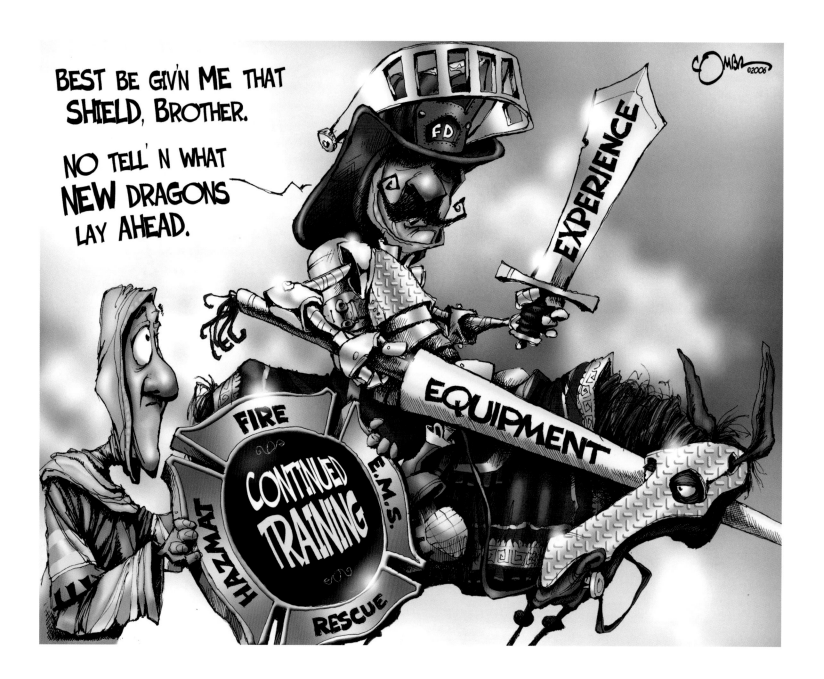

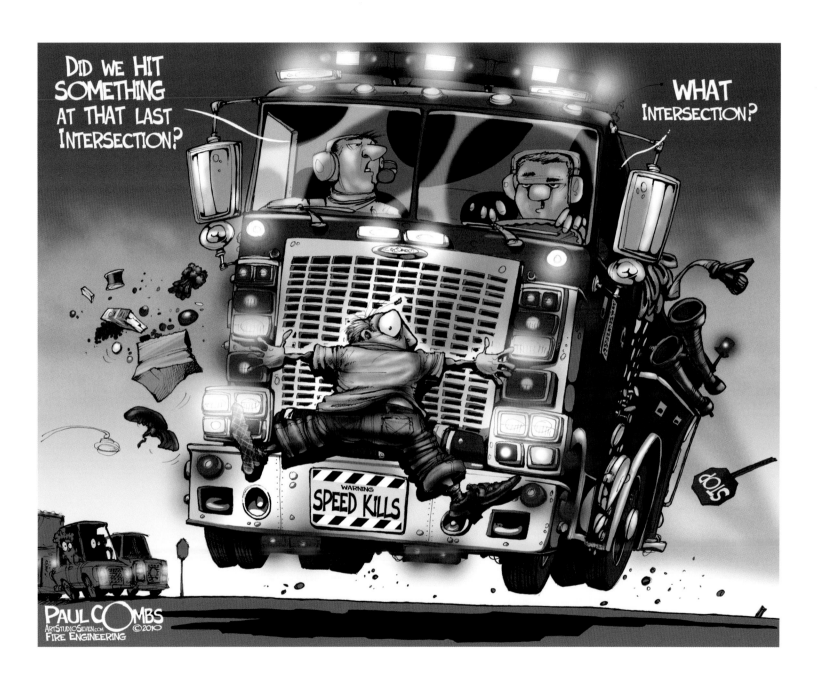

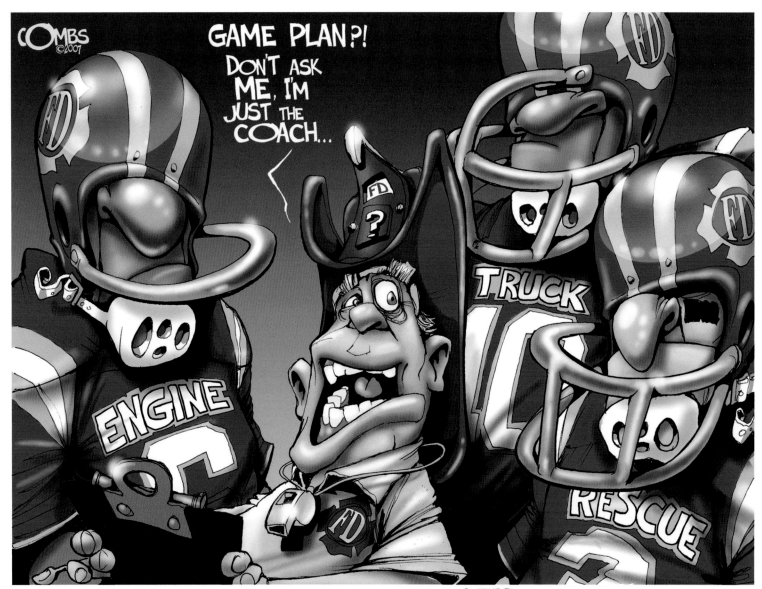

GET IN THE GAME AND LEAD!

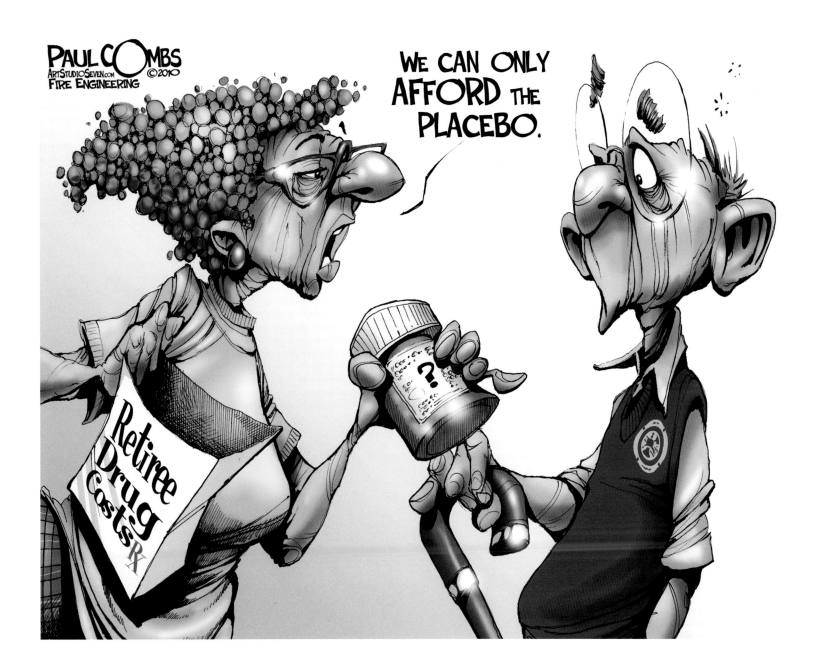

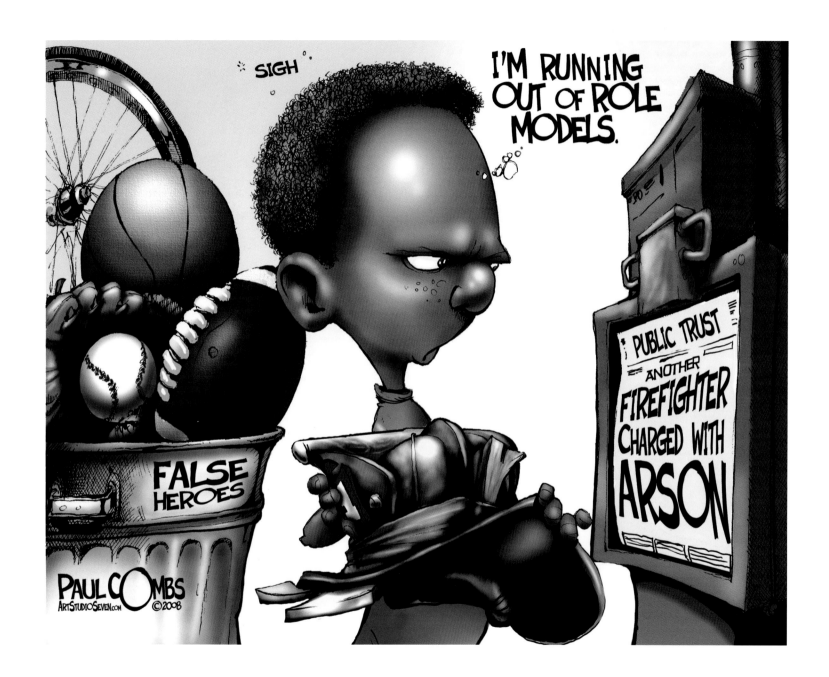

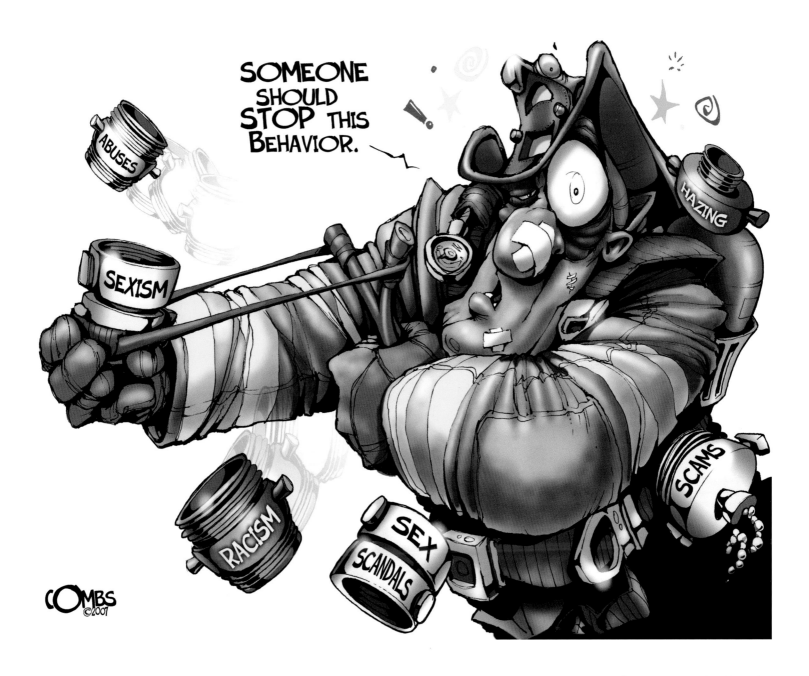

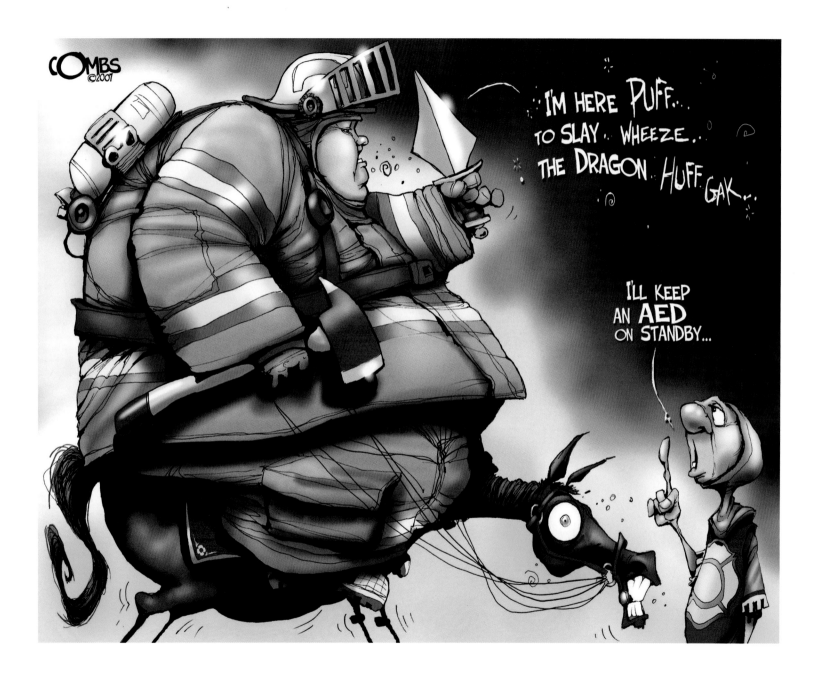

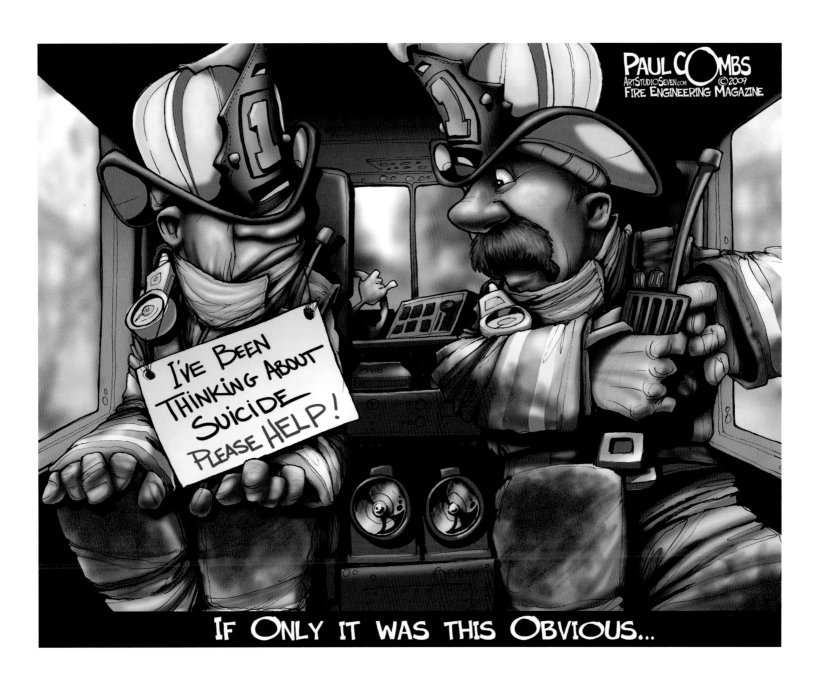

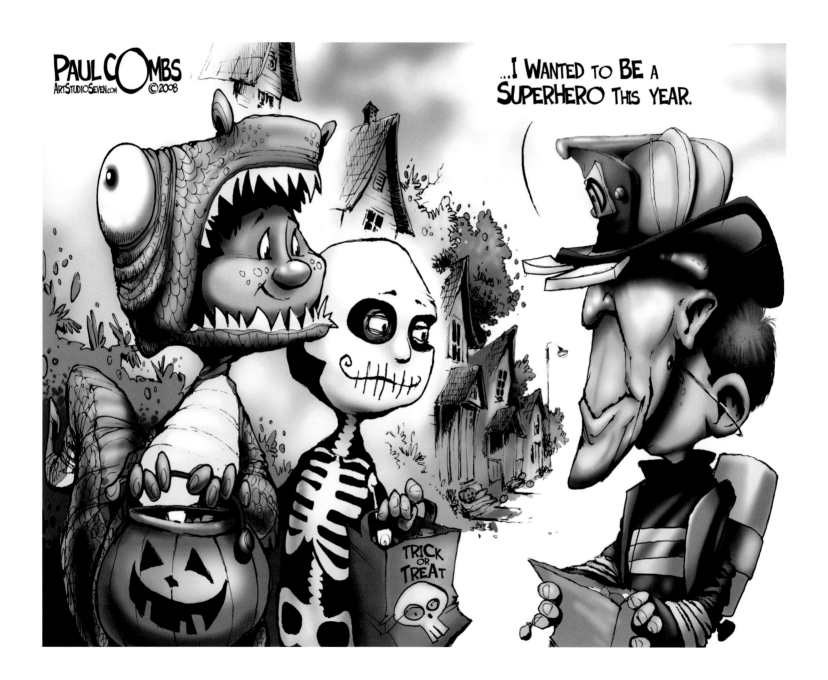

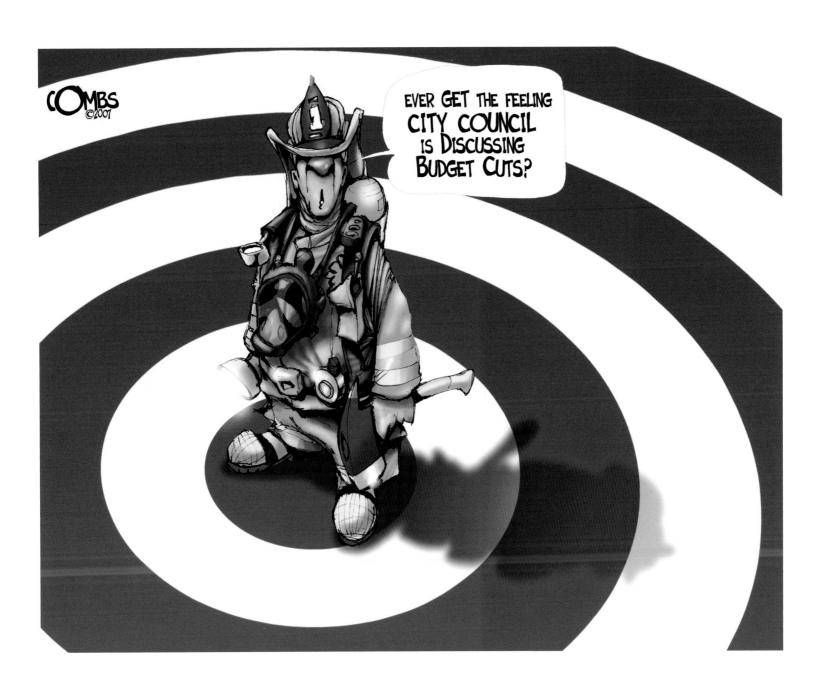

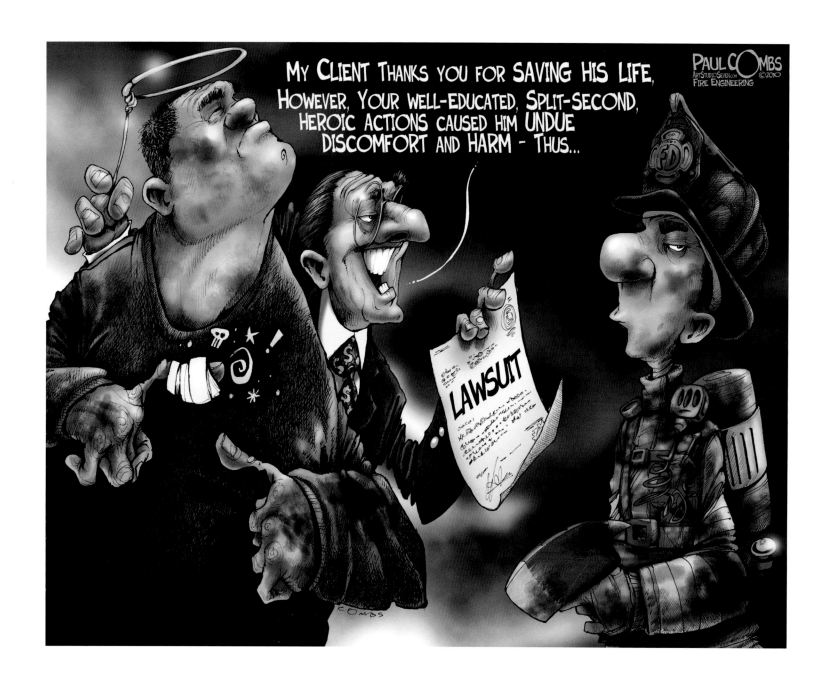

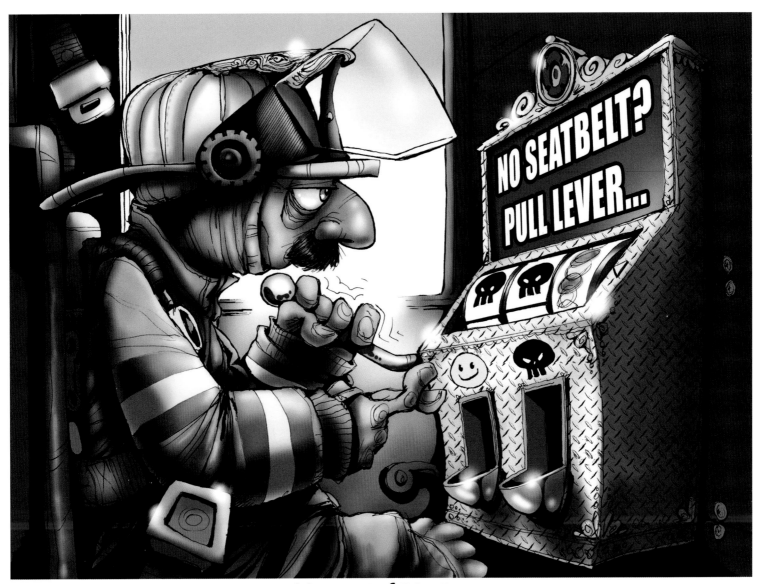

THE GAMBLER

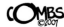

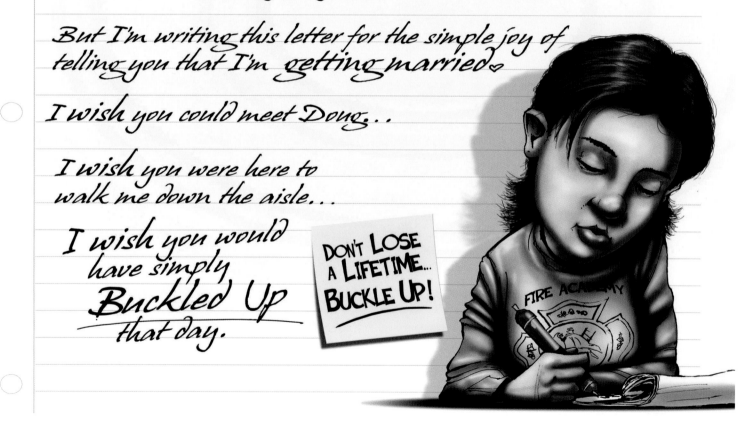

Dear Dad

You have been gone for nearly ten years now, and much has happened. I grew up strong and proud, just like you wanted. I graduated H.S. with honors, achieved a college degree and will graduate from the fire academy very soon.

But I'm writing this letter for the simple joy of telling you that I'm getting married

I wish you could meet Doug...

I wish you were here to walk me down the aisle...

I wish you would have simply Buckled Up that day.

DON'T LOSE A LIFETIME... BUCKLE UP!

COMBS ©2007

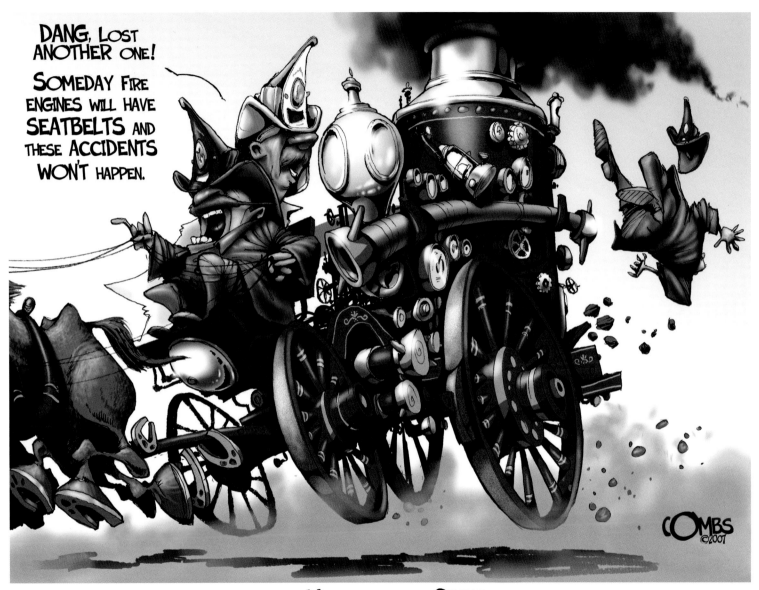

THE MORE THINGS CHANGE...

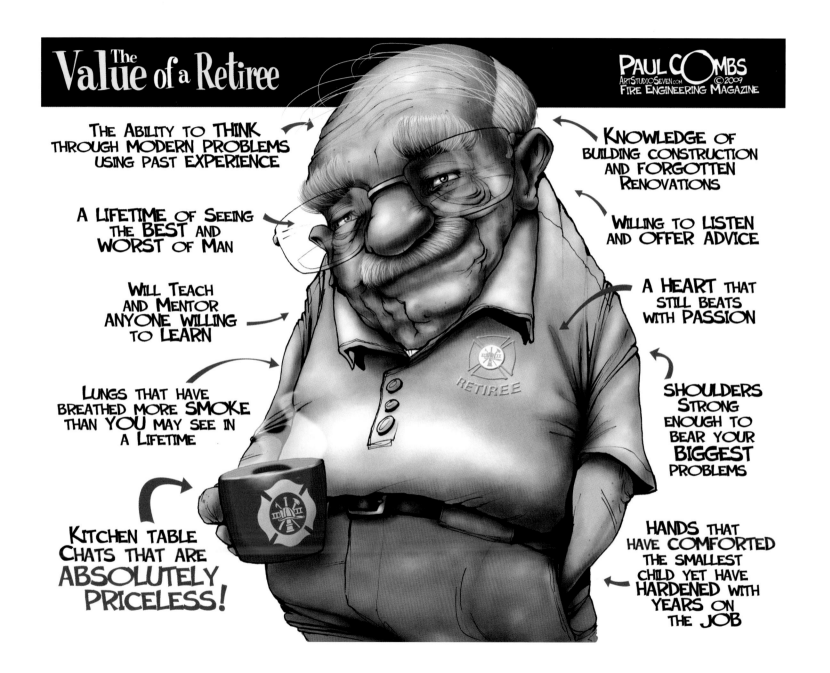

The Value of a Retiree

PAUL COMBS
ArtStudioSeven.com ©2009
Fire Engineering Magazine

The Ability to THINK through MODERN PROBLEMS using Past EXPERIENCE

KNOWLEDGE of BUILDING CONSTRUCTION AND FORGOTTEN RENOVATIONS

A LIFETIME of SEEING THE BEST AND WORST of MAN

WILLING TO LISTEN AND OFFER ADVICE

WILL TEACH AND MENTOR ANYONE WILLING TO LEARN

A HEART THAT STILL BEATS WITH PASSION

LUNGS THAT HAVE BREATHED MORE SMOKE THAN YOU MAY SEE IN A LIFETIME

SHOULDERS STRONG ENOUGH TO BEAR YOUR BIGGEST PROBLEMS

RETIREE

KITCHEN TABLE CHATS THAT ARE ABSOLUTELY PRICELESS!

HANDS THAT HAVE COMFORTED THE SMALLEST CHILD YET HAVE HARDENED WITH YEARS ON THE JOB

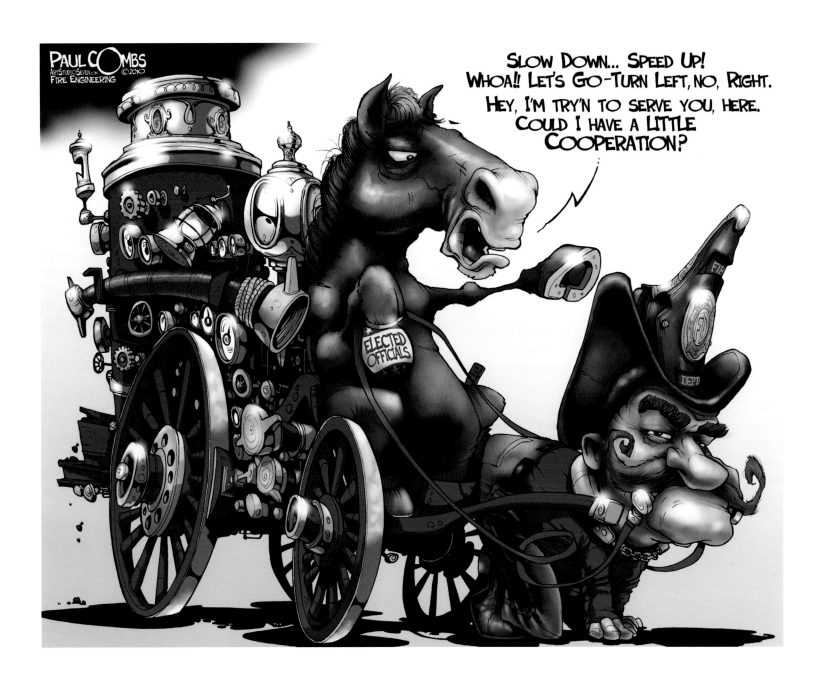

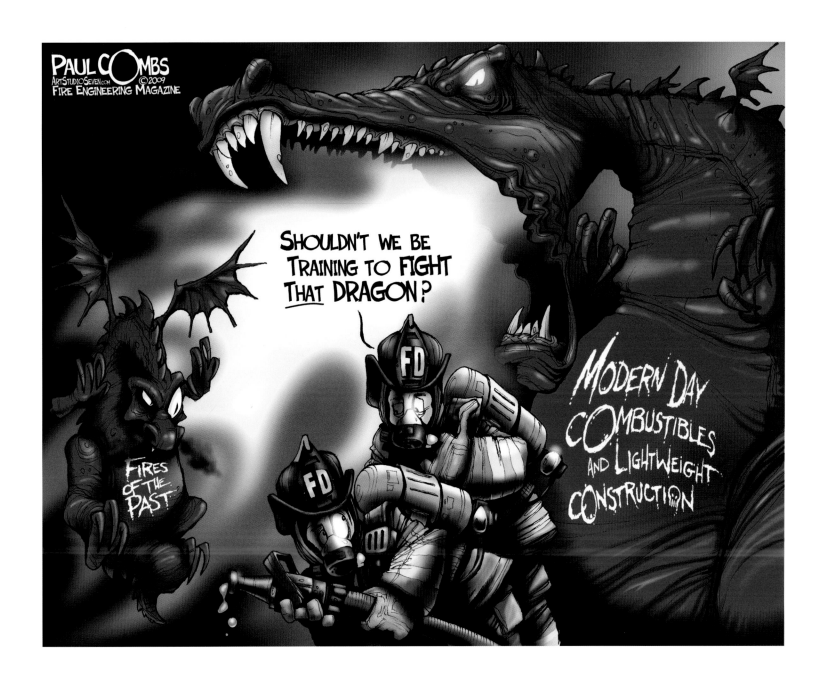

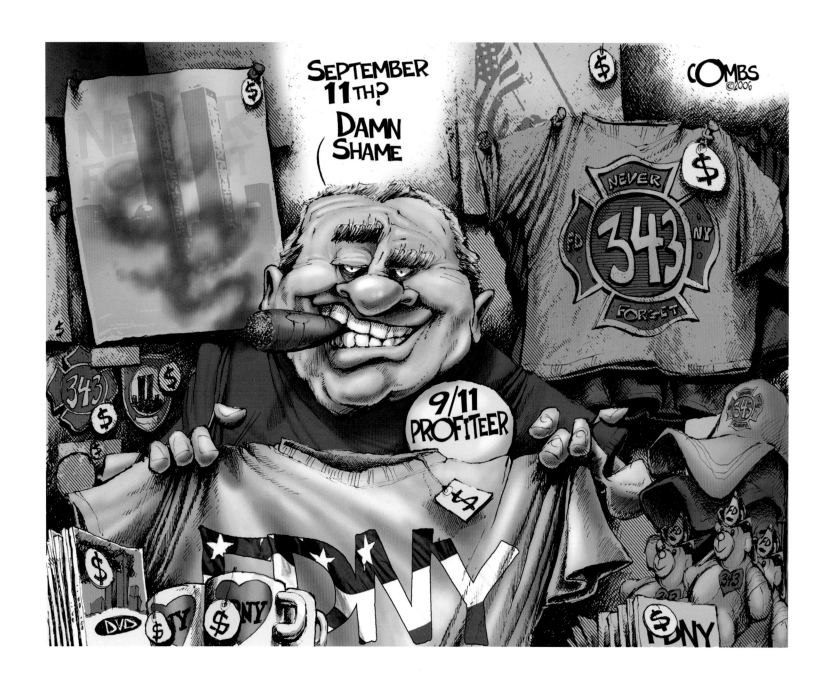

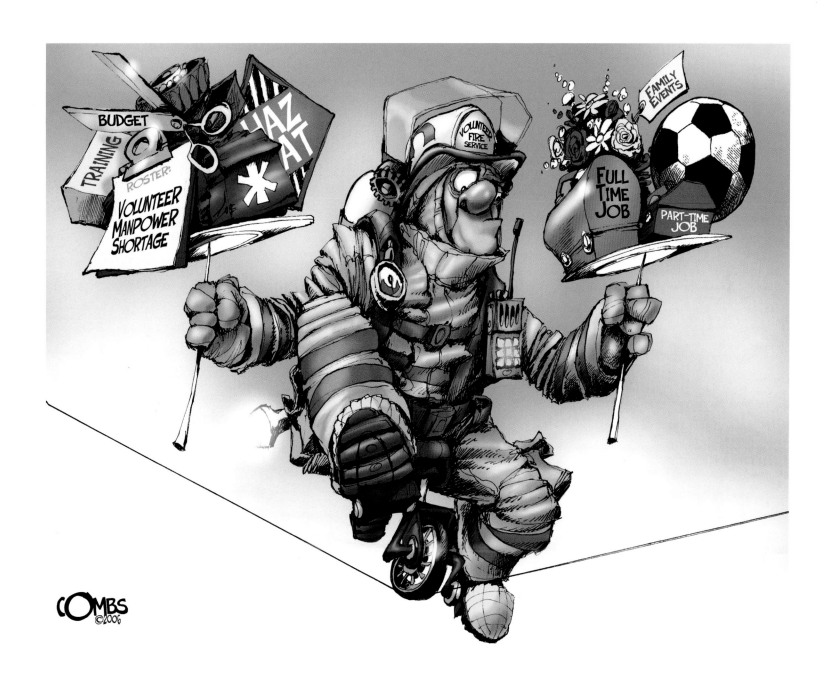

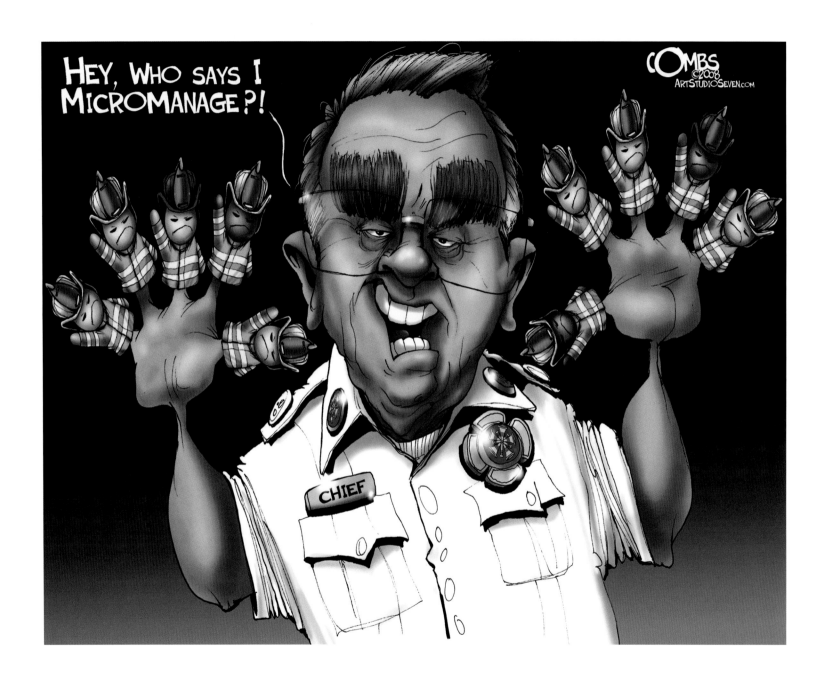